THE WORLD OF PRIVATE ISLANDS

EDITED BY FARHAD VLADI

NEW YORK STATE
Emerald Island
North Dumpling Island
Galloo Island
Stony Island
Thousand Islands

SCOTLAND
Isle of Gigha
Ailsa Craig
Oronsay
Isle of Eigg
Sanda Island

PARIS, SEINE
Île de Chantemesle

NORWAY
Hestskjæret
Bukkholmen
Tragerøy

ST. LAWRENCE RIVER
Boldt Castle
Singer Castle
Rock Island
Crossover Island

WASHINGTON
Allan Island

ONTARIO
Muskoka's Island World
Jacklin Island

NOVA SCOTIA
Hunt Island
Kaulbach Island
Oak Island
Mouton Island
Fish Island
Apple Island
Big La Mouna Island
Partridge Island
Sleepy Cove Island

CALIFORNIA
East Brother Island

BAJA CALIFORNIA
Isla de Altamura
Jaques Cousteau Island

CONNECTICUT, RHODE ISLAND, & NEW YORK
Davis Island
Potato Island
Mamenslae Kline Island
Robins Island
Gardiners Island

FLORIDA
Melody Key

BAHAMAS
Little Whale Cay
Bonefish Cay
Musha Cay
Bell Island
Little Darby Island
Little Hall's Pond Cay

IRELAND
Deenish Island
Coney Island

BALEARIC ISLANDS
Tagomago
Isla de sa Ferradura

PANAMA
Isla de Coco

CHANNEL ISLANDS & BRITTANY
Brecqhou
Île Saint-Riom
Île de Costaérès
Île Illiec
Île Louët
Le Gouffre
Île Biniguet

SWITZERLAND
Länggrien
Château de Chillon
Île de Salagnon
Isole di Brissago
Schloss Mauensee
Ufenau

FRENCH POLYNESIA
Motu Tautau
Motu Haapiti
Motu Tapu
Tiano
Tetiaroa
Tupai
Taiaro
Motu Toahotu
Motu Nao Nao

CHONOS ARCHIPELAGO
Traiguen Island

VIRGIN ISLANDS
Necker Island
Little Thatch Cay
Buck Island
Marina Cay
Guana Island
Norman Island
Cooper Island
Sandy Spit
Little St. James

WELTKARTE
WORLD MAP

GERMANY
Insel Liebitz

ITALY
Isola di Loreto
Santa Cristina

GREECE
Skorpios

MALDIVES
Mirihi
Soneva Gili

SEYCHELLES
D'Arros
St. Joseph Atoll
Frégate Island
North Island
Cousine Island
Chauve Souris Island

CAMBODIA
Koh Dek Koule

TASMAN SEA
Lord Howe Island

TASMANIA
Swan Island

FIJI
Laucala
Kaimbu
Vatu Vara

NEW ZEALAND
The Brothers
Pohuenui
Forsyth Island
Kaikoura Island

VORWORT
INTRO

Inseln haben mich schon als Kind in ihren Bann gezogen. Sie begleiteten mich durch meine Jugend – in meiner Lieblingsliteratur, auf Reisen, und auch in meinen beruflichen Wunschvorstellungen spielten sie stets eine Rolle.

In über 2 000 Inseltransaktionen und unzählige Inselvermietungen war ich von 1971 bis heute involviert. In diesen vergangenen 40 Jahren hat sich der Inselmarkt stark verändert.

Heute lässt sich auch das entferntest gelegene Eiland leicht erschließen: zum Beispiel dank hochmoderner Stromgewinnungs- und Wasseraufbereitungsanlagen, die alternative Energien nutzen. Daneben gibt es mittlerweile komfortabelste Fertighäuser, und auch die stark verbesserten technischen Möglichkeiten zu Ausbau und Nutzung einer modernen Infrastruktur haben die Inselwelt geprägt – ganz zu schweigen von der elektronischen Telekommunikation. Der Inselmarkt hatte plötzlich nicht nur eine erhöhte Nachfrage zu verbuchen, sondern erfreute sich vieler neuer Marktteilnehmer. Neben den privaten Käufern investierten nun auch die Betreiber von Inselresorts und luxuriösen Spas in die Paradiese in Flüssen, Seen oder den Meeren. Dazu kamen Unternehmen aus der Wind- und Solarenergie, der Telekommunikation und der Tourismusbranche.

Auch wurden Mietinseln, auf denen man für eine befristete und unbeschwerte Weile die Seele baumeln lassen kann, immer beliebter: Hier hat der Inselgast die Freiheit, jedes Jahr ein neues Refugium zu besuchen; außerdem ist er von der Inselverwaltung befreit.

Ich bin stolz und glücklich, die Entwicklung des Inselmarktes miterlebt und mitgestaltet zu haben. Es ist sehr schön, zu sehen, dass die allermeisten Inseln in Privathand mit Bedacht und Liebe zur Natur erschlossen wurden. Ein mit Hingabe erschlossenes Eiland wird für viele Eigentümer zu einem Familienmitglied – und dieses wieder herzugeben, fällt sehr schwer. Denn eine Insel hat keine Hausnummer, eine Insel hat eine Seele.

Islands have fascinated me ever since childhood. They accompanied me throughout my youth—always playing a role in my favorite literature, on trips, and in my career ambitions.

I was involved in over 2,000 island transactions and countless island lettings from 1971 till today. In these past 40 years, the island market has changed considerably.

Today, even the most remote island can be opened up easily: for instance, thanks to ultramodern facilities, which use alternative energies for generating electricity and processing water. In addition, there are, by now, the most comfortable prefabs, and much improved technical possibilities to develop and use a modern infrastructure have defined the island world—to say nothing of the electronic telecommunication. The island market had suddenly not only an increased demand to deal with, but also enjoyed the interest of many new market participants. In addition to private buyers, the operators of island resorts and luxurious spas also invested in the paradises located in rivers, lakes, and in the seas. Add to that wind and solar energy, telecommunication, and tourism companies.

And the popularity of rentable islands on which one can take a short break from everyday life grows exponentially. Here the island guest has the freedom to visit a new refuge every year; what is more, he is freed from managing the island.

I am proud and happy to have experienced and to have helped shape the development of the island market. It is very nice to see that most of the privately owned islands are opened up with care and love towards nature. For many owners, an island that has been opened up with devotion becomes a family member—and to part from it will be very difficult. For an island has no house number, an island has a soul.

Farhad Vladi
Vladi Private Islands

INHALTSVERZEICHNIS
CONTENT

ISLANDS WITH CASTLES

BOLDT CASTLE	14
SINGER CASTLE	16
BRECQHOU	18
ISOLA DI LORETO	20
CHÂTEAU DE CHILLON	22
ÎLE DE COSTAÉRÈS	24

CELEBRITY ISLANDS

MUSHA CAY	28
EMERALD ISLAND	30
LITTLE HALL'S POND CAY	31
NECKER ISLAND	32
SKORPIOS	34
LAUCALA	36
ÎLE ILLIEC	38
JACKLIN ISLAND	39
TIANO	40

EXCLUSIVELY FOR RENT

LITTLE WHALE CAY	44
ÎLE DE CHANTEMESLE	46
BONEFISH CAY	47
HUNT ISLAND	48
FORSYTH ISLAND	50
MELODY KEY	54
TAGOMAGO	55

ISLANDS WITH CHARMING RESIDENCES

LITTLE ST. JAMES	58
ISLA DE SA FERRADURA	60
LITTLE THATCH CAY	62
ISLE OF GIGHA	64
DAVIS ISLAND	65
KAULBACH ISLAND	66
BUCK ISLAND	68
BELL ISLAND	72

ISLANDS WITH LIGHTHOUSES

EAST BROTHER ISLAND	76
AILSA CRAIG	78
HESTSKJÆRET	80
THE BROTHERS	81
ÎLE LOUËT	82
NORTH DUMPLING ISLAND	83
ROCK ISLAND	84
CROSSOVER ISLAND	85

ISLANDS WITH THEIR OWN AIRSTRIPS

D'ARROS	88
GALLOO ISLAND	90
KAIKOURA ISLAND	92
ALLAN ISLAND	93
SWAN ISLAND	94
MOTU NAO NAO	96
LITTLE DARBY ISLAND	97

ATOLLS

TETIAROA	100
ST. JOSEPH ATOLL	102
TUPAI	104
KAIMBU	105
TAIARO	106

ISLANDS WITH RESORTS

KOH DEK KOULE	110
MARINA CAY	111
FRÉGATE ISLAND	112
GUANA ISLAND	116
MIRIHI	118
NORTH ISLAND	120
SONEVA GILI	124
COUSINE ISLAND	126
MOTU TAUTAU	130

TREASURE ISLANDS

LORD HOWE ISLAND	134
OAK ISLAND	135
ISLA DE COCO	136
NORMAN ISLAND	138

XXL ISLANDS

MOUTON ISLAND	144
COOPER ISLAND	148
GARDINERS ISLAND	149
ISLA DE ALTAMURA	150
JAQUES COUSTEAU ISLAND	152
STONY ISLAND	154
TRAIGUEN ISLAND	155
ORONSAY	156
POHUENUI	158
ISLE OF EIGG	160
VATU VARA	161

XXS ISLANDS

THOUSAND ISLANDS	164
SANDY SPIT	168
FISH ISLAND	170
POTATO ISLAND	171
CHAUVE SOURIS ISLAND	172
MOTU HAAPITI	174
MOTU TAPU	176
APPLE ISLAND	177
CONEY ISLAND	178
TRAGERØY	179
MAMENSLAE KLINE ISLAND	180
LE GOUFFRE	181
BUKKHOLMEN	182
ÎLE DE SALAGNON	183

LAKE AND RIVER ISLANDS

BIG LA MOUNA ISLAND	186
MUSKOKA'S ISLAND WORLD	188
ISOLE DI BRISSAGO	189
PARTRIDGE ISLAND	190
SCHLOSS MAUENSEE	192
UFENAU	193
SLEEPY COVE ISLAND	194

SELF-SUFFICIENT ISLANDS

ÎLE BINIGUET	198
SANTA CRISTINA	200
LÄNGGRIEN	204
SANDA ISLAND	206
INSEL LIEBITZ	210
DEENISH ISLAND	212
ÎLE SAINT-RIOM	214
MOTU TOAHOTU	216
ROBINS ISLAND	218

IMPRINT	220

DER TRAUM VON DER EIGENEN INSEL

Inseln faszinieren die Menschen seit jeher. Schon in der Antike wurde das von Meeren umtoste Land besungen, die Sagen der griechischen Mythologie rankten sich um die Eilande rund um den Peloponnes. Autoren aller Epochen ließen die Helden ihrer Geschichten an fremde Ufer spülen. Odysseus und Sindbad stehen für ein Heer von gestrandeten Protagonisten.

Orte, die dem Menschen unerreichbar und geheimnisvoll scheinen, beflügeln seine Phantasie. Allerdings galten Inseln, gerade da es immer einer strapaziösen Bootsreise bedurfte, um sie zu erreichen, jahrhundertelang als unwirtlich. Aus diesem Grund waren sie lange Zeit Orte zur Verbannung von Gefangenen, Kranken und anderen Unerwünschten. Höchstens ein Schiffbrüchiger erkannte in ihnen eine Zufluchtsstätte. Nicht selten sprach ein heimgekehrter Abenteurer stolz von entlegenen Eilanden, die zuweilen gar nicht existierten – schließlich garantierte eine Inselentdeckung den Heldenstatus.

Im 18. Jahrhundert wandelte sich der Blick allmählich: Forscher und Künstler, Philosophen und Literaten ergingen sich in romantischen Lobpreisungen der Landschaften im Meer. Das Leben in den großen Städten Europas wurde zunehmend von Beengtheit und Tristesse geprägt, als die paradiesisch klingenden Berichte des französischen Schriftstellers Louis-Antoine de Bougainville den Heimatkontinent erreichten. Der Weltumsegler war um einen wissenschaftlichen Ansatz bemüht und weit davon entfernt, Seemannsgarn zu spinnen. Doch nach Krankheiten und wachsender Verdrossenheit an Bord bedeutete der Aufenthalt auf Tahiti für die Schiffscrew einen Besuch im Garten Eden – und de Bougainville verklärte die polynesischen Inseln zu Orten des Friedens und der freien Liebe, ohne Eifersucht, Schuld oder Sünde. Ihre Ufer verhießen singende, gastfreundliche Menschen, sinnlich duftende Gärten und fruchtbehangene Palmen.

Den philosophischen Grundstein für eine Bewegung der Menschen zurück zur Natur hatte einige Jahre vor de Bougainvilles Schilderungen Tahitis der französisch-schweizerische Staatstheoretiker Jean-Jacques Rousseau gelegt. Seine Theorie des gesellschaftlichen Urzustandes vor dem zerstörenden Einfluss der Kultur stärkte den neuen Drang der urbanen Gesellschaft hinaus aus den freudlosen Städten. Inseln schienen hierfür der optimale Zufluchtsort zu sein. Auf ihnen, so hoffte man, könne ein idealer Staat möglich sein, wie ihn bereits Thomas Morus Anfang des 16. Jahrhunderts in „Utopia" beschrieben hatte: eine geschlossene, harmonische Gesellschaft, in der ein optimales Leben geführt wird.

Die leuchtenden Gemälde Paul Gauguins etwa ein Jahrhundert später vollendeten schließlich das Bild der Insel – und Tahitis im Besonderen – als Paradies auf Erden. Gauguin malte anmutig lächelnde Frauen und verschwenderisch bunte Blüten, seine Bilder erzählten von einem ungezähmten Leben. In den Sehnsuchtsvollen weckte jedes lockende Gemälde und jedes schwärmende Wort das Bedürfnis nach dem vollkommenen Ort: Der Mythos der ursprünglichen Insel als Stätte der Erfüllung war endgültig geboren. Tahiti ist bis heute die Mutter aller Orte romantischer Sehnsüchte – und alle Inseln der Welt sind Tahitis Kinder. Sie laden zum Träumen und Verweilen ein, hier kann man der Hektik und den Strapazen des Alltags entfliehen.

Wer mit der Natur in Einklang lebt, gilt als geduldiger, lernender und weiser Mensch. Wer sich von seiner Insel und dem Meer herum ernähren kann, fühlt sich dankbar vom Himmel beschenkt. Der Inselbewohner ist sein eigener Herr, er selbst bestimmt die Regeln, nach denen er lebt.

Unangemeldete Besucher gibt es kaum. Und falls doch einmal jemand das Ufer betritt, sind es naturliebende Segler, Fischer oder Einsamkeit suchende Liebende. Denn Inseln sind erotisch. Nirgends ist die Liebe ungestörter und ursprünglicher; unberührte Strände sind nicht nur im Mondenschein der begehrteste Ort für romantische Beteuerungen und Liebesschwüre.

So mancher Traum von glücklich und ohne Zwänge aufwachsenden Kindern spielt auf Inseln, die weitab von allem Bösen dieser Welt Geborgenheit versprechen. So setzte schon Friedrich Schiller in „Der spielende Knabe" den Mutterschoß einem Eiland mit schützenden Ufern gleich. Inseln schenken demnach eine Ahnung von Sicherheit: Kämpfe zwischen Kulturen und Religionen, Aufruhr und Krieg, Epidemien oder Hungersnöte finden im Inseltraum nicht statt. Zugleich verheißen die Eilande auch Abenteuer: Wer sie bereist, ist stets Entdecker und Forscher. Daniel Defoes Klassiker „Robinson Crusoe", der in fast alle Sprachen unserer Welt übersetzt wurde, entfacht die Abenteuerlust seit 300 Jahren stets aufs Neue.

Aber nicht nur Abenteurer oder Erholung Suchende sind von Inseln fasziniert. Auch vielen Landschaftsplanern dienen sie als Vorlage für künstlich geschaffenes Land, auf welchem neuer Lebensraum entstehen soll.

Inseln sind extreme Orte, mit denen der Mensch einerseits dunkle Geheimnisse und bedrohliche Wildheit assoziiert, andererseits kommen sie der menschlichen Vorstellung des irdischen Paradieses sehr nahe. Der Faden, aus dem all die Legenden gesponnen sind, die sich um Inseln ranken, besteht aus einem Teil Wahrheit, ein wenig Hoffnung, einer Hand voll Träumen und nicht zuletzt aus der alten Sehnsucht nach dem perfekten Ort.

Martina Matthiesen

PRIVATE ISLAND DREAMS

Islands have always fascinated humans. During Antiquity, songs were sung about the land surrounded by the sea, the legends of Greek mythology surround the isles around the Peloponnesus. Authors of all eras let their heroes be washed ashore foreign lands. Odysseus and Sinbad are but two of an army of stranded heroes.

Places that seem unattainable and mysterious inspire human imagination. However, since they always required a strenuous trip by ship, islands were considered to be inhospitable for centuries. This is why they were for many years a place to ban prisoners, the sick and other unwanted individuals. Only the occasional shipwrecked person took a refuge in them. Frequently, a returned adventurer spoke proudly of remote islands, which sometimes did not even exist—after all, the discovery of an island guaranteed the status of a hero.

In the 18th century, the image started to change: explorers and artists, philosophers and writers elaborately and romantically praised the landscapes in the sea. Life in Europe's large cities was increasingly dominated by constriction and melancholy, when the heavenly-sounding reports of the French writer Louis-Antoine de Bougainville reached his native continent. The circumnavigator of the globe was interested in a scientific reporting approach and his stories were by no means sailor's yarn. But, following illness and increasing moroseness on board, the stay on Tahiti was to the ship's crew a veritable visit to the Garden of Eden—and de Bougainville transfigured the Polynesian islands to havens of peace and free love, free of jealousy, guilt, and sin. Their shores promised singing, welcoming people, sensuously scented gardens, and palm trees laden with fruit.

The philosophical basis for a movement of people back to nature was created a few years prior to Bougainville's reports of Tahiti by the French-Swiss state theoretician Jean-Jacques Rousseau. His theory of society's primitive state before the destructive influence of culture fuelled the new desire of the urban society to leave the cheerless cities. Islands seemed to be the perfect refuge in this regard. On them, it was hoped, it would be possible to create the ideal state, similar to the one described by Thomas More in the early 16th century in "Utopia"—a closed harmonious society, leading the perfect life.

The glowing paintings of Paul Gauguin around a century later complemented the image of islands—and Tahiti in particular—as paradise on earth. Gauguin painted gracefully smiling women and lavishly colorful flowers, his paintings spoke of an untamed life. For the yearning individuals, each alluring painting and each effusive word awoke the longing for the perfect place—the myth of the natural island as a place of fulfillment was irrevocably born. To this day, Tahiti remains the mother of all places of romantic longings for escape—and all islands of the world are Tahiti's offspring. They are an invitation to dream and linger, a place to escape the hustle and bustle and strains of everyday life.

Those who live in accordance with nature are considered to be patient, learning, and wise people. Those who can sustain themselves from their island and the sea surrounding it, feel grateful to the heavens for this gift. Island dwellers master their own fate, setting the rules they live by.

Unannounced visitors are rare. If people do step on the shore, they usually are nature-loving sailors, fishermen, or lovers seeking isolation. Islands are erotic. Nowhere else is love as undisturbed and unmarred as on them; not only in the moonlight are unspoiled beaches the most sought-after setting for romantic scenes and love oaths.

Many a dream of children growing up happy and free takes place on islands, that promise shelter far away from all the evil in the world. Already Friedrich Schiller compared the mother's lap to an island with protective shores in "Der spielende Knabe" ("The Boy at Play"). Islands thus provide a sense of security: struggles between cultures and religions, turmoil and war, epidemics or famine do not take place in the island dream. At the same time, the isles promise adventure: who visits them is always an explorer and researcher. Daniel Defoe's classic "Robinson Crusoe," which has been translated into almost all languages of the earth, continues to rekindle the love for adventure anew for the past 300 years.

But islands do not fascinate only adventurers and leisure seekers. They also serve as models for many landscape planners for artificially created land for new living space.

Islands are the site of extremes. On the one hand, people associate them with dark secrets and threatening wilderness, on the other hand they come very close to the human picture of paradise on earth. The thread from which all the legends surrounding islands are spun consists of one part truth, a little hope, a handful of dreams, and, last but not least, the old longing for the perfect place.

Martina Matthiesen

INSELN MIT BURGEN UND SCHLÖSSERN
ISLANDS WITH CASTLES

So manch ein anspruchsvoller Träumer sehnt sich nach einem Leben im eigenen Schloss. Befindet sich dieses dann noch auf einer privaten Insel, ist der Wunsch nach einem autarken kleinen Reich gänzlich erfüllt. Es haben mittlerweile mehr Inselkäufer ihren Doppeltraum von Insel und Schloss verwirklicht, als diese doch sehr luxuriös anmutende Kombination vermuten lässt.

Man findet in fast allen Erdteilen Schloss- oder Burginseln in privatem Eigentum; jede für sich ist in ihrem Zusammenspiel aus Natur und Architektur ein Unikat. Solch ein imposantes Bauwerk auf einer Insel zu errichten, erfordert eine besonders enge und präzise Zusammenarbeit zwischen Bauherrschaft und Handwerk. Die charakteristischen, schweren Steinblöcke samt allem übrigen benötigten Material über das Wasser zu transportieren, ist eine logistische Herausforderung. Und man muss bedenken: Viele der Inselschlösser oder -schlösschen wurden bereits vor 100 Jahren errichtet, Stein auf Stein in Handarbeit; eine architektonische und organisatorische Meisterleistung. Die meisten solcher Bauwerke verfügen über einen oder mehrere Türme oder sind zumindest mehrere Stockwerke hoch, sodass die Bewohner eine wunderbare Aussicht über das eigene Stückchen Land bis hin zu seinen Ufern genießen.

Privatinseln mit Schlössern bieten sich an, um darin Boutiquehotels einzurichten, Privatkliniken, Resorts oder als Ausflugsziele für den Tagestourismus: Singer Castle auf Dark Island in Upstate New York in den Thousand Islands heißt jährlich bis zu 40 000 Besucher willkommen. Die Gäste genießen die Tour durch das antik eingerichtete Schloss und seine alten Geheimgänge. Singer Castle ist außerdem ein beliebter Ort für Hochzeiten: In der Royal Suite haben schon viele frischvermählte Paare genächtigt.

Many a discerning dreamer longs for a life in his or her own castle. And the yearning for a self-sufficient little kingdom is completely realized if the castle also happens to stand on a private island. By now, more island buyers have realized their double dream of an island and a castle than this admittedly very luxurious-seeming combination suggests.

In almost every part of the world, there are privately owned islands with mansions and castles, every one of which is unique in its interplay of nature and architecture. In order to build such an imposing construction on an island, it is necessary to have a very close and precise collaboration between the building contractor and the craftsmen. It is a logistical challenge to transport the typical, heavy blocks of stone and all of the other required materials over the water. And one has to consider: Many of the big and small castles on islands have been built as far back as 100 years ago, stone upon stone by hand; an architectural and organizational master stroke. Most of these buildings feature one or more towers or are at least several stories high, in order for the inhabitants to enjoy a magnificent view over their own piece of land down to its shores.

Private islands with castles are well suited for the installation of boutique hotels, private clinics, and resorts, or as excursion destinations for day-trip tourism: Singer Castle on Dark Island in Upstate New York in the Thousand Islands welcomes 40,000 visitors every year. The guests enjoy the tour through the antiquely furnished castle and its old secret passageways. Moreover, Singer Castle is a favorite location for weddings: quite a number of newlyweds have spent their night in the Royal Suite.

BOLDT CASTLE 14

SINGER CASTLE 16

BRECQHOU 18

ISOLA DI LORETO 20

CHÂTEAU DE CHILLON 22

ÎLE DE COSTAÉRÈS 24

ST. LAWRENCE RIVER, NEW YORK, USA
BOLDT CASTLE

Um 1900 erwarb George C. Boldt, der Eigentümer des Waldorf Astoria Hotels in New York, diese herzförmige Insel, gab ihr den Namen Heart Island und ließ darauf ein Schloss für seine geliebte Frau Louise errichten. Der Bau im Stil eines rheinischen Herrschaftssitzes ist heute eine beliebte Touristenattraktion in den Thousand Islands.

Around 1900, George C. Boldt, owner of the Waldorf Astoria Hotel in New York, bought this heart-shaped island, gave it the name Heart Island, and had a castle built on it for his beloved wife Louise. Today, the edifice in the style of a Rheinish castle is a popular draw for tourists in the Thousand Islands.

ST. LAWRENCE RIVER, NEW YORK, USA
SINGER CASTLE

Mystisch-romantische Gerüchte ranken sich seit jeher um Dark Island und das Singer Castle, das nach der Vorlage einer schottischen Burg erbaut wurde. Geheimgänge zwischen Zimmern und Etagen, eine Falltür und Ritterrüstungen versetzen die vielen Touristen bei Führungen in eine längst vergangene Zeit. Will man dieses Flair etwas länger genießen, kann man das Singer Castle auch mieten oder sogar dort heiraten und sich anschließend in die Schloss-suite zurückziehen.

Mystical and romantic rumors have always been surrounding Dark Island and the Singer Castle, which was built after the model of a Scottish mansion. Secret passageways between rooms and floors, a trapdoor, and knight's armors transport the many tourists to a long forgotten time. If you want to relish this flair a little longer, you can also rent Singer Castle or even marry there and afterwards retire to the castle suite.

ISLANDS WITH CASTLES 17

CHANNEL ISLANDS, UNITED KINGDOM
BRECQHOU

Wie eine Festung ragt das weiße Schloss in der Inselmitte empor und erhebt sich 70 Meter über den Meeresspiegel. Die Barclay-Zwillinge, Miteigentümer großer Tageszeitungen in Großbritannien, ließen das Anwesen Mitte der 90er Jahre erbauen und leben hier in ersehnter Abgeschiedenheit. Seit 1999 geben die Eigentümer der Insel jährlich eine eigene Briefmarke heraus.

The white castle in the middle of the island resembles a fortress and rises 230 feet above sea level. The Barclay twins, co-owners of big daily newspapers in Great Britain, had the estate built in the mid-1990s and live here in longed-for seclusion. Every year since 1999, the owners of the island have been issuing their own postage stamp.

LAKE ISEO, ITALY
ISOLA DI LORETO

Schon im Jahr 400 nach Christus sollen Nonnen hier ein Kloster gegründet haben, und Archäologen fanden Mauerreste einer Kapelle, die um 1500 auf der Isola di Loreto stand. Seit 100 Jahren ragt ein Schloss im neogotischen Stil vor der dunkelgrünen Bergkulisse aus dem See, der sich zwischen Brescia und Bergamo, unweit des Gardasees, erstreckt.

Way back in the year 400 AD, nuns are believed to have founded a monastery here, and archaeologists recovered mural remains from a chapel that stood on the Isola di Loreto at around 1500. For 100 years now, in front of a dark-green mountain backdrop, a castle in a neo-Gothic style towers above the sea, which stretches from Brescia to Bergamo, not far from Lake Garda.

ISLANDS WITH CASTLES

LAKE GENEVA, SWITZERLAND
CHÂTEAU DE CHILLON

Das Panorama über den Genfer See mit Blick auf die französischen Alpen bis hin zum Mont Blanc ist atemberaubend, und das Château de Chillon mit seiner über tausendjährigen Geschichte als Wasserburg rundet die Kulisse ab. Schon in der Bronzezeit war die Insel bewohnt und diente später als Zollstation zwischen Wasser- und Landwegen.

The panorama over Lake Geneva with a view of the French Alps and up to the Mont Blanc is breathtaking and the Château de Chillon with its over 1,000-year-long history as a moated castle completes the scenery. As far back as the Bronze Age, the island was inhabited and was later in use as a customs station between waterways and land routes.

ISLANDS WITH CASTLES

BRITTANY, FRANCE
ÎLE DE COSTAÉRÈS

Ganz sanft gebärdet sich der Atlantik in dieser malerischen Bucht vor der bretonischen Küste, und wenn die Felsen der Côte de Granit Rose im Abendlicht rosafarben leuchten, ist die Idylle nicht mehr zu übertreffen. Auf Costaérès kann man sich als Schlossherr einmieten und durch die Gemächer wandeln, in denen Nobelpreisträger Henryk Sienkiewicz seinen Roman „Quo vadis" schrieb.

Very gently does the Atlantic sea conduct itself in this painterly bay in front of the Breton coast, and when the rocks of the Côte de Granit Rose glow pinkish in the evening light, the idyll cannot be surpassed. You can take lodgings in Costaérès as lord of the manor and walk through the rooms where Nobel Prize winner Henryk Sienkiewicz wrote his novel "Quo Vadis."

ISLANDS WITH CASTLES 25

INSELN VON BERÜHMTEN PERSÖNLICHKEITEN
CELEBRITY ISLANDS

Privatinseln und Prominente: Sie scheinen ohneeinander nicht auszukommen. Die wohl berühmtesten Inseleigentümer waren die Schauspiellegende Marlon Brando, der auf seinem geliebten Atoll Tetiaroa entspannte, und der griechische Reeder Aristoteles Onassis. Sein letzter Wunsch war es, auf seiner Insel Skorpios begraben zu werden.

Obwohl – oder gerade weil – viele der erfolgsverwöhnten Celebritys in den Metropolen weltweit hofiert werden und zuhause sind, suchen sie auf ihrer eigenen oder der gemieteten Insel das geerdete Leben in und mit der Natur. Sie genießen den Luxus exquisiter Resorts und lassen sich in den gehobenen Insel-Spas verwöhnen. Doch das funktioniert nur, wenn diese im Einklang mit der Umwelt geführt werden und es möglich machen, die schnelle und künstliche Großstadtwelt für eine Weile zu vergessen. Einer „meiner" Inselliebhaber sagte einmal: „Meine Insel ist die Apotheke meiner Seele."

Die meisten Berühmtheiten, die etwas Abgeschiedenheit auf kleinen oder großen Eilanden suchen und sich unerkannt bewegen möchten, kommen aus dem Show-Business oder sind international bekannte Wirtschaftsgrößen.

Private Islands and celebrities: they seem unable to part from each other. The most famous island owners were probably acting legend Marlon Brando, who relaxed on his beloved atoll Tetiaroa, and the Greek shipping magnate Aristotle Onassis. His last wish was to be buried on his island Skorpios.

Although—or precisely because—many of the celebrities are spoiled by success, are always paid court to by somebody, and are at home in the metropolises all around the world, they seek on their own or on rented islands a grounded life in and with nature. They enjoy the luxury of exquisite resorts and let themselves be pampered in upscale island spas. But this only works if these establishments are administered in harmony with the environment and if they make it possible to forget the fast and artificial life of the big city for a while. One of "my" island enthusiasts once said: "My island is the pharmacy for my soul."

Most of the celebrities who seek some seclusion on a small or large island and who would like to move freely without being recognized originate from show business or are internationally known heavy hitters of economy.

MUSHA CAY	28
EMERALD ISLAND	30
LITTLE HALL'S POND CAY	31
NECKER ISLAND	32
SKORPIOS	34
LAUCALA	36
ÎLE ILLIEC	38
JACKLIN ISLAND	39
TIANO	40

EXUMAS, BAHAMAS
MUSHA CAY

Wenn der Magier David Copperfield vom glitzernden Las Vegas genug hat, tauscht er es gegen das türkise Glitzern der Karibik rund um Musha Cay ein. Sein traumhafter Zweitwohnsitz in den südlichen Bahamas erstreckt sich über 60 Hektar und ist von drei kleineren Inseln eingerahmt, die absolute Privatsphäre garantieren – für jeden, der die Insel mieten will.

When magician David Copperfield has enough of glittering Las Vegas, he swaps it for the turquoise glitter of the Caribbean around Musha Cay. His dreamlike secondary residence in the southern Bahamas spans over 150 acres and is framed by three smaller isles which guarantee absolute privacy—for everyone who wants to rent the island.

NEW YORK, USA
EMERALD ISLAND

Gediegen und altenglisch mutet es an in dem rustikalen Anwesen aus grauem Naturstein. Mehrere Kamine und aufwendige Holzverkleidungen schaffen ein behagliches Ambiente. Ein kleiner, von Bäumen gesäumter Privatdamm verbindet die Insel mit dem Ufer, doch sonst ist man auf den 3,5 Hektar ganz für sich. Brooke Shields lebte einige Jahre auf Emerald Island und genoss, umgeben von hohen Bäumen, die Abgeschiedenheit mitten im Chazy Lake, der zum wunderschönen Adirondacks Park gehört.

The rustic estate made out of grey natural stone appears dignified and Old English. Many chimneys and elaborate wood paneling create a comfortable ambience. A small, tree-lined private dam connects the island to the shore, but apart from that you are all by yourself on the 8.5 acres. Brooke Shields lived on Emerald Island for some years and enjoyed, while surrounded by high trees, the seclusion in the middle of Chazy Lake, which belongs to the gorgeous Adirondacks Park.

EXUMAS, BAHAMAS
LITTLE HALL'S POND CAY

Sicherlich waren es die Dreharbeiten zu „Fluch der Karibik", die Johnny Depp bewogen, ebendort nach einem einsamen und paradiesischen Rückzugsort zu suchen. Fündig wurde er in der Exuma-Inselkette auf den Bahamas: Little Hall's Pond Cay verzauberte den Hollywood-Star mit üppiger Vegetation, sechs schneeweißen Stränden und einer von Palmen umgebenen Lagune. Nur ein kleiner Steg für seine Yacht verbindet die Insel mit der Außenwelt. Handyempfang? Fehlanzeige. Damit Little Hall's Pond Cay das Juwel bleibt, in das sich der Schauspieler verliebt hat, schafft er bereits bei seinen Kindern ein Bewusstsein für den Naturschutz.

It was certainly the shoot for "Pirates of the Caribbean" which lead Johnny Depp to search at the same place for a lonely and paradisiac safe haven. He made a find in the Exuma chain of islands in the Bahamas: Little Hall's Pond Cay enchanted the Hollywood star with lush vegetation, six snow-white beaches, and a lagoon surrounded by palm trees. Only a small landing stage for his yacht connects the island to the outside world. Mobile reception? No chance! In order for Little Hall's Pond Cay to remain the jewel the actor fell in love with, he already encourages his children to develop a sense for nature preservation.

BRITISH VIRGIN ISLANDS, CARIBBEAN
NECKER ISLAND

Sir Richard Branson, der Gründer von Virgin Records, besitzt inzwischen von einer Airline bis zum privaten Raumschiff eigentlich alles, was man besitzen kann. Mit einer eigenen Karibikinsel, die er auch vermietet, hat er sein Virgin-Imperium vervollständigt: Dass das kleine Paradies zu den Virgin Islands gehört, versteht sich wohl von selbst.

Sir Richard Branson, the founder of Virgin Records, by now owns virtually anything that can be owned, from his own airline to a private spaceship. He completed his Virgin empire with a very own Caribbean island, which he also rents out: it probably goes without saying that the little paradise belongs to the Virgin Islands.

CELEBRITY ISLANDS

IONIAN SEA, GREECE
SKORPIOS

Als der griechische Reeder und Milliardär Aristoteles Onassis am 20. Oktober 1968 Jackie Kennedy das Ja-Wort gab, schaute die ganze Welt auf Skorpios. Onassis liebte diesen Ort und verbrachte hier viel Zeit mit seiner Familie. Neben ihm liegen auch sein Sohn Alexander und Tochter Christina zwischen den sanften Hügeln der Insel begraben. Mit Athina als Erbin ist Skorpios im Familienbesitz geblieben.

When the Greek shipping magnate and billionaire Aristotle Onassis married Jackie Kennedy on the 20th of October, 1968, the whole world looked at Skorpios. Onassis loved this place and spent a lot of time with his family here. His son Alexander and daughter Christina lie buried next to him between the gentle hills of the island. Skorpios has remained a family property with Athina as heiress.

CELEBRITY ISLANDS 35

FIJI
LAUCALA

Jenseits der Nordost-Küste von Taveuni liegt Laucala mit seinem einzigartigen 5-Sterne-Resort. Die Betreiber verfolgen vom Interieur bis zur Küche eine ganzheitliche Philosophie im Einklang mit der exotischen Natur des Südpazifik. Der Verleger Malcolm Forbes kaufte die Insel 1972 und fand hier auch seine letzte Ruhe. Heute ist Laucala im Besitz eines österreichischen Geschäftsmanns.

Laucala lies with its singular five star resort beyond the northeastern coast of Taveuni. From the interior to the kitchen, the operators adhere to a holistic philosophy in accordance with the exotic nature of the South Pacific. The publisher Malcolm Forbes bought the island in 1972 and was also laid to rest here. Today, an Austrian businessman owns Laucala.

BRITTANY, FRANCE
ÎLE ILLIEC

Als er sich aus der Öffentlichkeit zurückziehen wollte, erwarb der amerikanische Pilot Charles Lindbergh, dem die erste Alleinüberquerung des Atlantiks gelungen war, 1938 die Île Illiec zum fabelhaften Preis von 16 000 Dollar, was etwa einem Dollar pro Quadratmeter entsprach. Heute gehört das bretonische Schmuckstück der Familie Heidsieck.

In 1938, when American pilot Charles Lindbergh, who was the first to complete a transatlantic solo flight, planned on withdrawing from the public, he bought Île Illiec at the fabulous rate of 16,000 dollars, which is about one dollar per square yard. Today, this small Breton jewel is owned by the Heidsieck family.

ONTARIO, CANADA
JACKLIN ISLAND

Seit mehr als 20 Jahren ist Jacklin Island im Besitz von Peter Munk, einem kanadischen Geschäftsmann, dem die weltweit größte Firma für Goldabbau gehört. Seine Insel in der Georgian Bay, die er liebevoll ein „Familienmitglied" nennt, befindet sich in Nachbarschaft zu mehreren 10 000 Inseln mit charakteristischen Felsbuchten und Kalksteinklippen.

For more than 20 years, Peter Munk, a Canadian businessman who possesses the world's largest gold mining company, has owned Jacklin Island in the Georgian Bay, which he affectionately calls a "family member." It lies in the neighborhood of several 10,000 islands with distinctive rocky bays and limestone cliffs.

RAIATEA ATOLL, SOCIETY ISLANDS, FRENCH POLYNESIA
TIANO

Viele Jahre lang war Tiano für Diana Ross eine zweite Heimat. Die Sängerin verbrachte in den 80er Jahren sogar ihre Flitterwochen hier. Eine Villa im polynesischen Stil und ein komfortables Gästehaus krönen das kleine Südseeparadies.

For many years, Tiano was a second home to Diana Ross. The singer even spent her honeymoon here in the '80s. A villa in the Polynesian style and a comfortable guesthouse crown this small South Seas paradise.

CELEBRITY ISLANDS 41

INSELN ZUM MIETEN
EXCLUSIVELY FOR RENT

Viele der in diesem Buch gezeigten Inseln kann man auch mieten. Ein eigenes Eiland nur mit der Familie oder mit Freunden zu teilen, ist eine besonders schöne Urlaubserfahrung, die nachhaltig in Erinnerung bleiben wird. Die Mietinseln lassen sich in zwei Kategorien unterteilen: Zum einen gibt es die Selbstversorgerinseln, auf denen der Mieter alleine für sich sorgt. Er bringt Lebensmittel mit und genießt das Kochen und die Ruhe. Auf den Service-Inseln dagegen wird man rundum verwöhnt. Das Personal lebt entweder auf der Insel oder kommt und geht täglich. Hier wird fast jede gewünschte Dienstleistung erbracht, vom Catering über die Reinigung der luxuriösen Unterkunft und Wäscheservice bis hin zur Organisation von Ausflügen, dem Boot- und Yachtcharter und diversen Sportangeboten an Land oder im Wasser.

Für die meisten Inseleigentümer wirkt sich die Vermietung positiv aus. Die Mieteinnahmen helfen, die laufenden Unterhaltungskosten einer Insel zu decken. Viel wichtiger ist jedoch, dass die operativen Räder der Insel in Betrieb bleiben. Die Ausstattung wird gewartet, Boote, Motorräder, Generatoren und alle technischen Geräte des Hauses befinden sich stets in gutem Zustand, und das Wohnhaus ist immer gepflegt. Der Mieter auf der anderen Seite hat den großen Vorteil, eine Privatinsel ohne jede eigene Verwaltungsverantwortung genießen zu können. Und er hat die Freiheit, sich jedes Jahr eine andere Insel zu mieten. Dieses Konzept funktioniert für viele Privatinseln mit großem Erfolg.

Many of the islands shown in this book are also for rent. To share your own island only with family members or with friends is a particularly lovely holiday experience, which will stay in your memory for a long time. The islands for hire can be divided into two sections: On the one hand, there are self-sufficient islands on which the tenant takes care of himself. He brings along the groceries and enjoys the cooking and the quietude. On the service islands, on the other hand, you will be completely indulged. The staff either lives on the island or comes and goes every day. Here almost every service you could wish for is taken care of, from catering, trips, charterboats and yachts, the cleaning of the luxurious dwellings and laundry service, right up to various on- and offshore sporting activities.

For most of the island owners, leasing has its positive effects. The rental revenues help to cover the ongoing maintenance costs of an island. Much more important, though, is to keep the operational wheels of the island going. The equipment has to be maintained, boats, motorbikes, generators, and all technical devices of the house are always in good condition, and the residential house is always well-kept. The tenant on the other side has the big advantage to enjoy a private island without any of his own responsibility in terms of maintenance. And he has the freedom to rent a different island every year. This concept works for many private islands with great success.

LITTLE WHALE CAY ... 44

ÎLE DE CHANTEMESLE 46

BONEFISH CAY ... 47

HUNT ISLAND ... 48

FORSYTH ISLAND .. 50

MELODY KEY ... 54

TAGOMAGO .. 55

BERRY ISLANDS, BAHAMAS
LITTLE WHALE CAY

Ein kleiner Hafen, eine eigene Landepiste und genug Platz für Wasserflugzeuge lassen die Entscheidung offen, wie man sich dem Paradies nähern möchte. Von Nassau aus sind es zum Beispiel nur 20 Flugminuten nach Little Whale Cay. Bis zu zwölf Gästen liest ein 13-köpfiges Personal in diesem Refugium jeden Wunsch von den Augen ab. Allein für die gepflegten, subtropischen Parkanlagen, in denen Flamingos und Pfaue leben, sind drei Gärtner zuständig, die dafür sorgen, dass die Insel dem Bild vom Garten Eden recht nahe kommt. Der Infinity-Pool mit Blick aufs Meer, Tennisplatz und Spa-Einrichtungen scheinen angesichts dieses Luxus fast schon selbstverständlich zu sein. Das Highlight ist die romantische Inselkapelle, in der Hochzeitszeremonien in exklusivem Kreis stattfinden können.

A small harbor, a private airstrip, and enough space for water planes allow for a wide choice of travel options when it comes to making a trip to this paradise. A flight from Nassau to Little Whale Cay takes a mere 20 minutes. As many as twelve guests can stay at this private retreat where a staff of 13 do their best to anticipate every wish. Three gardeners are employed only to maintain the subtropical parks where flamingos and peacocks roam, and, of course, to keep the island as similar to the Garden of Eden as possible. Amidst such extraordinary luxury, the infinity-pool with ocean view, the tennis court, and the spa facilities almost go without saying. A special highlight is the small, romantic chapel where wedding ceremonies can be held in a private circle.

RIVER SEINE, ÎLE DE FRANCE, FRANCE
ÎLE DE CHANTEMESLE

Nordwestlich von Paris, etwa 50 Kilometer die Seine hoch, liegt die zauberhafte Insel Chantemesle mit ihren beiden Villen. Eine davon wird von den Besitzern, einer Pariser Familie, auch vermietet. Giverny und der berühmte Garten von Claude Monet, in dem seine zahlreichen Seerosen-Gemälde entstanden, befinden sich ganz in der Nähe.

The magical island of Chantemesle with its two villas is located about 30 miles down the Seine, to the northwest of Paris. The owners, a Parisian family, also rent out one of the buildings. Giverny and the famous garden of Claude Monet, where he created his numerous water lily paintings, are very close by.

EXCLUSIVELY FOR RENT

ABACOS, BAHAMAS
BONEFISH CAY

Wo einst nur Sand lag, hat sich in den vergangenen Jahren ein karibischer Traum der Spitzenklasse entwickelt. Für die Ausstattung der fünf Gebäude importierte man feinste Materialien aus Europa und Nordamerika. Bonefish Cay, benannt nach den Grätenfisch-Schwärmen, die hier ihr Revier haben, verfügt sogar über eine eigene Meerwasser-Entsalzungsanlage.

Where once there was only sand, a top class Caribbean dream has evolved over the past years. For the equipment of the five buildings, the owners imported some of the finest materials from Europe and North America. Bonefish Cay, named after the bonefish shoals that have their territory here, even features its very own seawater desalination plant.

NOVA SCOTIA, CANADA
HUNT ISLAND

Wenn der Indian Summer das Laub bunt färbt, bietet sich auf Hunt Island dank der dichten Bewaldung ein einzigartiges Farbspiel aus Gelb-, Rot- und Ockertönen, rundum leuchtet der Ponhook Lake in tiefem Blau und ist ein Eldorado für Angler. Das Interieur im Haupthaus greift auf natürliche Materialien zurück und strahlt komfortable Behaglichkeit aus.

When the Indian Summer colors the leaves, a unique play of colors, composed of yellow, red, and ocher shades, adorns Hunt Island with its thick forests. Ponhook Lake glows all around in the deepest blue and is an El Dorado for anglers. The interior of the main building employs natural materials and radiates comfortable coziness.

EXCLUSIVELY FOR RENT

MARLBOROUGH SOUNDS, NEW ZEALAND
FORSYTH ISLAND

EXCLUSIVELY FOR RENT 51

FORSYTH ISLAND ist eine subtropische Trauminsel. Von der Terrasse der großzügigen Lodge aus, die auf einem der Bergplateaus thront, schweift der Blick über sattgrüne Hänge und Steilklippen bis auf den Pazifik und die faszinierende Inselwelt der Marlborough Sounds. An den bewaldeten Bergkämmen grasen schneeweiße Kaschmirziegen, die für Neuseeland typischen Schafe und drei zahme Lamas. Dazwischen kann man das Nationalsymbol, den Kiwi, beobachten. Dank der landschaftlichen Vielfalt und der Nähe zur Nord- und Südinsel Neuseelands mit ihren Vulkanen, Thermalquellen und Regenwäldern – Wellington liegt nur 20 Minuten per Helikopter entfernt – sind die Möglichkeiten an Aktivitäten fast unbegrenzt. Auf Forsyth Island stehen ein Motorboot, Kajaks, ein Jeep und Mountainbikes zur Verfügung, dazu gibt es ein Wanderwegenetz über 50 Kilometer, das entdeckt werden will.

FORSYTH ISLAND is a subtropical dream island. From the terrace of the generous lodge, which sits enthroned on a mountain plateau, the look wanders over the rich green slopes and bold cliffs up to the Pacific and the fascinating island world of Marlborough Sounds. Snow-white cashmere goats graze on the forested hillsides alongside sheep typical of New Zealand and a group of three llamas. The national symbol of New Zealand, the kiwi, can be seen here and there. The list of possible activities is virtually endless, thanks to the diverse landscape, the proximity to both the North and South Island of New Zealand with their volcanoes, thermal springs, and rain forests, and Wellington, which can be reached in 20 minutes by helicopter. A motorboat, kayaks, and mountain bikes are available on Forsyth Island, not to mention a network of more than 30 miles of hiking paths waiting to be discovered.

FLORIDA, USA
MELODY KEY

Etwa 40 Kilometer vor der Küste Floridas liegt dieses Kleinod im kristallklaren Wasser. Umgeben von einem Palmenhain wohnt man in einer cool designten Villa. Auf 2 Hektar kann man ganz ungestört die Seele baumeln lassen und nichts tun oder, wie der ehemalige Inselbesitzer und Musiker Nick Hexum, inspiriert von der Traumkulisse das nächste Erfolgsalbum komponieren.

About 25 miles from the coast of Florida, this gem lies in crystal clear waters. You reside in a coolly designed villa surrounded by a palm grove. On 5.5 acres and without any disruption, you can leave all your cares behind and do nothing or, like the former owner of the island, musician Nick Hexum, compose the next hit album inspired by the dream scenery.

BALEARIC ISLANDS, SPAIN
TAGOMAGO

Abseits des lauten und bunten Lebens auf Ibiza (und doch nah genug, falls man sich in aufregende Partynächte stürzen will) liegt Tagomago, eine der wenigen Privatinseln im Mittelmeer, die man mieten kann. Die felsige Insel mitten im türkisblauen Wasser ist ein Ort der Ruhe und Entspannung und wird für abgeschiedene Familienurlaube ebenso gemietet wie als Location für exklusive Business-Events. Das vollkommen private Paradies mit eigenem Ankerplatz erstreckt sich über 40 Hektar, gekrönt von einer luftigen Luxusvilla, die das Lebensgefühl der Balearen stylish und modern interpretiert.

Apart from the loud and colorful life on Ibiza (and yet still close enough for those who want to throw themselves into exciting party nights) lies Tagomago, one of the few rentable private islands in the Mediterranean Sea. The rocky island amidst turquoise blue water is a place of quietude and relaxation and is rented out for private family trips as well as for exclusive business events. The completely private paradise with its own anchoring place spans over 98 acres, crowned by a breezy luxury villa interpreting the sense of life of the Balearic Islands in a stylish and modern fashion.

INSELN MIT LIEBHABERRESIDENZEN
ISLANDS WITH CHARMING RESIDENCES

Jeder Inselliebhaber, der in ein so besonderes Stück Land wie eine See-, Fluss- oder Meeresinsel investiert, vollendet sein neues Refugium gerne mit der Wohnimmobilie seines Herzens. So finden sich hochklassige Anwesen auf Privatinseln, die in ihrer Bauart und Erscheinung wie moderne Schlösser wirken. Seinerzeit krönte der vermögende Inseleigentümer seinen Besitz mit einem Schloss, heute mit einer Villa.

Es gibt wunderbare, und ganz offensichtlich luxuriöse Inselresidenzen. Daneben findet man Häuser, die in ihrem Stil schlichter sind, doch mit besonders edler Bauqualität beeindrucken. Kleine, aus gutem Holz in liebevoller Handarbeit erbaute Cottages fallen ebenso in die Kategorie Liebhaberresidenzen, weil sie das besondere Inselgefühl bewahren und das passende Ambiente bieten für friedvolle Tage im Kreise der Familie oder Freunde. Solange der Bauherr sein künftiges Wohnhaus in die Natur integriert und dem Charakter seiner Insel anpasst, wird er mit dem Ergebnis glücklich sein.

Every island aficionado who invests in a piece of land that is as special as a lake island, a river isle, or a deep-sea island, likes to complete his new refuge with a real estate to his liking. Thus high-class estates are to be found on private islands, which seem like modern castles in their design and appearance. Back then, the wealthy owner of the island crowned his island with a castle, today, he does so with a villa.

There are wonderful and quite obviously luxurious island residences. In addition, there are houses whose style is plainer, but they impress with a particularly upscale quality of construction. Small cottages made out of good wood and by a loving hand also belong to the category of charming residences in as much as they retain the special island feeling and offer a fitting ambience for peaceful days within the circle of family or friends. As long as the building contractor integrates his future dwelling house into nature and adapts to the personality of the island, he will be happy with the result.

LITTLE ST. JAMES	58
ISLA DE SA FERRADURA	60
LITTLE THATCH CAY	62
ISLE OF GIGHA	64
DAVIS ISLAND	65
KAULBACH ISLAND	66
BUCK ISLAND	68
BELL ISLAND	72

58 ISLANDS WITH CHARMING RESIDENCES

US VIRGIN ISLANDS, CARIBBEAN
LITTLE ST. JAMES

Ein luxuriöser Villenkomplex in strahlendem Weiß thront auf einem Plateau am äußersten Zipfel von Little St. James. Von hier aus lässt man den Blick schweifen – über die sanften Hügel der Insel und ihre schneeweißen Buchten bis hin zu den Segelyachten, die wie Spielzeugboote vor der Küste der Nachbarinsel St. Thomas liegen.

A luxurious villa complex in gleaming white sits enthroned on a plateau on the outermost tip of Little St. James. From here, the look travels over the gentle hills of the island and its snow-white bays down to the sailing yachts, which lie like toy boats off the coast of the neighboring island St. Thomas.

BALEARIC ISLANDS, SPAIN
ISLA DE SA FERRADURA

In der Bucht von San Miguel beherbergt Ferradura eine Hacienda de luxe, eingebettet in einen großzügigen, tropisch inspirierten Garten mit Grotten, Wasserfällen und Blick auf die felsige Küste von Ibiza. Die Partyatmosphäre und das entspannte Lebensgefühl der Nachbarinsel schwappen herüber, nur feiert man hier exklusiver: auf der Dachterrasse mit Dancefloor, an einer der Bars oder in der privaten, typisch spanischen Bodega.

In the bay of San Miguel, Ferradura houses a Hacienda de luxe, nestled in a generous, tropically inspired garden with grottos, waterfalls, and a view onto the rocky coast of Ibiza. The party atmosphere and the relaxed attitude to life of the neighboring island spills over. Here, however, partying is more exclusive: on the roof terrace with a dance floor, at one of the bars, or in the private, characteristically Spanish bodega.

BRITISH VIRGIN ISLANDS, CARIBBEAN
LITTLE THATCH CAY

Little Thatch Cay erstreckt sich über 22 Hektar und kann von Tortola aus in wenigen Minuten per Boot erreicht werden. Erst vor wenigen Jahren entschlossen sich die britischen Eigentümer, die Privatinsel bewohnbar zu machen. Herausgekommen ist ein kleines, edles Anwesen auf dem Inselplateau mit Rundumblick, das sich perfekt in die subtropische Kulisse einfügt und zu den malerischsten Plätzen der Karibik gehört. Das Cottage direkt am Strand kann man mieten.

Little Thatch Cay spans over 54 acres and can be reached from Tortola by boat in just a couple of minutes. It was a few years ago that the British owners decided to make their private island habitable. The result is a small, precious estate on an island plateau with a 360-degree view that fits perfectly into the subtropical scenery and is among the most picturesque places of the Caribbean. The cottage right on the beach is for rent.

ISLANDS WITH CHARMING RESIDENCES 63

SCOTLAND, UNITED KINGDOM
ISLE OF GIGHA

Mick Jagger hätte Gigha gern sein Eigen genannt, allerdings verpasste er den Zuschlag um wenige Pfund. Heute besitzen und verwalten die 156 Inselbewohner ihre grüne Idylle selbst. Besucher wohnen in einem herrschaftlichen Hotel oder als Selbstversorger in einem der rustikalen Cottages.

Mick Jagger would have liked to call Gigha his own, but he failed to win the bid by a few pounds. Today, the 156 inhabitants of the island own and manage the green idyll on their own. Visitors stay in a grand hotel or as self-supporters in one of the rustic cottages.

ISLANDS WITH CHARMING RESIDENCES

CONNECTICUT, USA
DAVIS ISLAND

Im Zentrum von Davis Island steht das prachtvolle viktorianische Wohnhaus, das sich US-Präsident William Howard Taft während seiner Amtszeit von 1909 bis 1913 als Sommerresidenz wählte und von wo er seine Amtsgeschäfte ausübte. Das modernisierte Anwesen ist heute eine ideale Urlaubsresidenz an der Atlantikküste.

At the center of Davis Island stands the grand Victorian house which U.S. President William Howard Taft chose as his summer residence during his incumbency from 1909 to 1913 and from where he performed his official duties. Today, the modernized estate is an ideal holiday residence on the Atlantic coast.

NOVA SCOTIA, CANADA
KAULBACH ISLAND

Südlich von Halifax liegt Kaulbach Island mit seinen 23 Hektar an Nadelwald, weitläufigen Wiesen und Strand. Das großzügige Herrenhaus mit Blick auf den Atlantik ist im Stil der Villen auf Cape Cod erbaut, das geschmackvolle Interieur zeigt kanadisch-rustikales Wohnen von seiner elegantesten Seite.

Kaulbach Island with its 57 acres of conifer forest, copious meadows, and a beach lies south of Halifax. The generous manor house with a view on the Atlantic has been built in the style of the villas on Cape Cod, the luxurious interior shows rustic Canadian living from its elegant side.

ISLANDS WITH CHARMING RESIDENCES

BRITISH VIRGIN ISLANDS, CARIBBEAN
BUCK ISLAND

BUCK ISLAND liegt mitten im Sir Francis Drake Kanal, einem Eldorado zum Tiefseefischen oder Segeln. Wenn die Eigentümer lieber festen Boden unter den Füßen behalten, können sie die drei Anhöhen der Insel erklimmen und das unbeschreibliche Panorama genießen. In der privaten Residenz aus Naturstein kommen die liebevollen lateinamerikanischen Details perfekt zur Geltung.

BUCK ISLAND lies in the middle of the Sir Francis Drake canal, an El Dorado for deep sea fishing and sailing. When the owners prefer to keep their feet firmly on the ground, they can climb up to the three hills of the island and enjoy the indescribable panorama. In the private residence made of natural stone, the affectionate Latin-American details come to perfect fruition.

ISLANDS WITH CHARMING RESIDENCES 71

EXUMAS, BAHAMAS
BELL ISLAND

So muss das Paradies aussehen: weiße Sandstrände, Mangroven und Palmenhaine, dazu ein ultramodernes und luxuriöses Resort aus Glas, damit nichts den traumhaften Ausblick versperrt. Bell Island gehört zum Exuma Land and Sea Park, einem Naturschutzgebiet mit Korallenriffen von einzigartiger Schönheit.

This is how paradise should look like: white sand beaches, mangroves, and palm groves, including an ultra modern and luxurious resort made out of glass, so that nothing blocks the wonderful view. Bell Island belongs to the Exuma Land and Sea Park, a nature reserve with coral reefs of singular beauty.

ISLANDS WITH CHARMING RESIDENCES 73

INSELN MIT LEUCHTTÜRMEN
ISLANDS WITH LIGHTHOUSES

Im vergangenen Jahrhundert wählte man Inseln in Küstennähe oft als Standorte für Leuchttürme, um vorüberziehenden oder heimkehrenden Seeleuten den Weg zu weisen. Seit dieser Zeit ist mit Leuchttürmen auch die Sehnsucht nach einem Ort der Ruhe und des Friedens verbunden.

Damals waren die Leuchttürme bemannt, weil die Technologie den automatischen Leuchtturmbetrieb noch nicht kannte. Manchmal lebte die Familie des Leuchtturmwärters mit auf der Insel, dann gab es neben dem Turm und dem Betriebsgebäude auch ein Wohnhaus.
Als die Elektronik nach und nach die menschlichen Leuchtturmwärter ersetzte, wurden viele dieser Inseln verkauft; nicht in allen Fällen blieb ein Licht zurück, das automatisch betrieben wurde. Viele der neuen, privaten Eigentümer bauten die Leuchttürme in maritime Ferienhäuser um – dem Meer näher zu sein als hier, ist kaum möglich.

Einige dieser Leuchtturminseln lassen sich inzwischen mieten, manchmal finden sich auf ihnen sogar ein kleines Hotel und ein Restaurant. War das Leuchtturmleben früher für eine hart arbeitende und genügsame Familie gemacht, so bietet es heute eine romantische Gemütlichkeit. Stürme und das weite Nichts um einen herum muss man allerdings immer noch lieben.

In the past century, islands near the coast were often chosen as locations for lighthouses, in order to show the way to passing or homecoming sailors. Ever since this time, lighthouses are also intertwined with the yearning for a place of quietude and peace.

Back then, lighthouses were manned because there was no technology that allowed to operate them automatically. Sometimes, the family of the lighthouse keeper lived along with him on the island. In such cases, there also stood a tenement next to the tower and the operations building. When electronics replaced the human lighthouse keepers over time, many of these islands were sold; there was not always a light left behind that could run automatically. Many of the new, private owners reconstructed the lighthouses into maritime vacation homes—it is almost impossible to be closer to the sea than from here.

By now, some of these lighthouse islands are for rent; at times there is even a little hotel and a restaurant to be found on them. While, in the past, life in a lighthouse was made for a hard-working and modest family, today, it offers romantic coziness. However, one still needs a soft spot for the storms and the wide nothingness surrounding oneself.

EAST BROTHER ISLAND	76
AILSA CRAIG	78
HESTSKJÆRET	80
THE BROTHERS	81
ÎLE LOUËT	82
NORTH DUMPLING ISLAND	83
ROCK ISLAND	84
CROSSOVER ISLAND	85

CALIFORNIA, USA
EAST BROTHER ISLAND

Die Bucht von San Francisco blieb den spanischen Entdeckern bis 1769 verborgen, weil sie oft in dichtem Nebel lag. Bei klarer Sicht genießt man von East Brother Island aus, wo 133 Jahre lang Leuchtturm und Nebelsignal in Betrieb waren, einen unvergleichlichen Blick auf die Skyline. Und in den fünf Gästezimmern des sorgsam restaurierten Wärterhauses lassen sich Inselfeeling, Leuchtturmabenteuer und Viktorianisches Zeitalter zugleich erleben.

San Francisco Bay remained hidden to Spanish explorers until 1769, because often it remained shrouded by a thick fog. On a clear day, one can enjoy an incomparable look at the skyline from East Brother Island, where for 133 years a lighthouse and a fog signal were in use. And in the five guest rooms of the carefully renovated home of the lighthouse keeper, island feeling, lighthouse adventure, and the Victorian Age can be experienced at once.

ISLANDS WITH LIGHTHOUSES 77

SCOTLAND, UNITED KINGDOM
AILSA CRAIG

Wie eine ebenmäßige Halbkugel ragt die Insel etwa 16 Kilometer vor der schottischen Westküste aus dem Meer. Der Leuchtturm ist an dieser Stelle mitten in der Irischen See, die Großbritannien von Irland trennt, für die Sicherheit der Seefahrt unverzichtbar. Übrigens ist es nicht die unverwechselbare Form, für die Ailsa Craig bekannt ist, sondern der Steinbruch, aus dessen Granit die angeblich hochwertigsten Curlingsteine produziert werden.

The island rises out of the sea like a well-proportioned hemisphere about 10 miles from the Scottish west coast. For seafaring safety, the lighthouse is indispensable at this place in the middle of the Irish Sea, which parts Great Britain from Ireland. Incidentally, it is not the unmistakable shape Ailsa Craig is known for, but the stone quarry whose granite is used to produce the reportedly finest curling stones in the world.

ISLANDS WITH LIGHTHOUSES 79

MØRE OG ROMSDAL, NORWAY
HESTSKJÆRET

Das Wetter rund um Hestskjæret wird manchmal ziemlich ungemütlich, was im Laufe der Jahrhunderte einige Schiffe in Seenot gebracht hat. In einer Tiefe von 15 bis 38 Metern können Taucher unmittelbar vor der Insel die Reste von zwei Schiffswracks aus dem 18. und 19. Jahrhundert erkunden, immer begleitet von Kabeljau, Seelachs, Seeteufeln, Hummern und Krabben.

The weather around Hestskjæret can sometimes get quite uncomfortable, which over the centuries caused some ships to get into distress at sea. In a depth of 50 to 125 feet, right in front of the island, divers can explore the remnants of two shipwrecks from the 18th and 19th century, always accompanied by codfish, coalfish, anglerfish, lobsters, and prawns.

COOK STRAIT, NEW ZEALAND
THE BROTHERS

Als James Cook 1770 als erster Europäer die Straße zwischen der Nord- und der Südinsel Neuseelands entlangsegelte, eine der gefährlichsten Passagen der Welt, gab es auf den Brothers noch keinen Leuchtturm, der die Seefahrer an der kleinen, felsigen Inselgruppe vorbeilotste.

In 1770, when, as the first European, James Cook sailed along the street between the North and South Island of New Zealand, one of the most dangerous passages in the world, the Brothers still lacked a lighthouse that guided the sailors past the little, rocky archipelago.

BRITTANY, FRANCE
ÎLE LOUËT

Im Jahr 1962 wurde der Leuchtturm auf Louët automatisiert und der Leuchtturmwärter in Rente geschickt. Wer heute sein einstiges Wohnhaus mietet, muss sich nicht mehr um Leuchtsignale kümmern, sondern kann sich ganz der wild-romantischen Einsamkeit hingeben.

In 1962, the lighthouse on Louët turned automatic and the lighthouse keeper was retired. Today, those who rent his former abode do not have to take care of light signals anymore, and can give themselves up completely to the wildly romantic loneliness.

NEW YORK, USA
NORTH DUMPLING ISLAND

Weil ihm ursprünglich der Bau einer Wind- und Solarenergieanlage auf der Insel untersagt worden war, erklärte der Privateigentümer seine – nicht ganz ernst gemeinte – Abspaltung von den USA. Heute verfügt das „Königreich North Dumpling" nicht nur über eine private Stromversorgung, sondern auch über eine eigene Flagge, Währung und Nationalhymne.

Because the construction of a wind and solar energy plant on the island had been initially prohibited, the private owner proclaimed his—not quite serious—separation from the United States. Today, the "Kingdom of North Dumpling" possesses not just a private electricity supply, but also its very own flag, currency, and national hymn.

ST. LAWRENCE RIVER, NEW YORK, USA
ROCK ISLAND

Rock Island war die erste aus der Gruppe der Thousand Islands im St. Lawrence River, auf der die Vereinigten Staaten 1847 einen Leuchtturm bauen ließen, um den Wasserweg zum Lake Ontario sicherer zu gestalten. Über 50 Jahre lang veränderte man Position und Höhe des Turms immer wieder, bis die Zahl der Schiffsunglücke endlich abnahm.

Rock Island was the first spot in the Thousand Islands archipelago in St. Lawrence River where the United States chose to erect a lighthouse. It was built in 1847 to guarantee safe passage to Lake Ontario, but it took more than 50 years of relocating it and changing its height until the number of shipping accidents finally dropped.

ST. LAWRENCE RIVER, NEW YORK, USA
CROSSOVER ISLAND

In jenem Abschnitt des St. Lawrence River, wo wenige 100 Meter vom Inselufer entfernt amerikanisches und kanadisches Hoheitsgebiet aufeinandertreffen, lässt sich auf Crossover Island in einem stillgelegten Leuchtturm das Nichtstun zelebrieren. Das Haus des Leuchtturmwärters stammt aus dem Jahr 1848 und wird seit 1960 als privater Wohnsitz genutzt, wodurch Haupt- und Nebengebäude gut erhalten sind. Rund um die Insel beobachtet man regen Schiffsverkehr, wenn Frachter und Passagierschiffe den Fluss in Richtung Lake Ontario bis nach Toronto passieren.

In those upper reaches of the St. Lawrence River, where a few hundred yards from the island's shore American and Canadian sovereign territory meet, one can celebrate sweet idleness in an abandoned lighthouse on Crossover Island. The house of the lighthouse keeper originates from the year 1848 and is used as a private residence since 1960, because of which the main and the adjacent building are in good condition. Busy ship traffic can be witnessed all around the island when freighters and passenger ships pass the river in direction of Lake Ontario up until Toronto.

INSELN MIT EIGENER LANDEBAHN
ISLANDS WITH THEIR OWN AIRSTRIPS

Durch eine eigene Landebahn lässt sich auch die abgelegenste Insel besser erreichen. Das gilt nicht nur für die Anreise des Eigentümers, die so um einiges bequemer wird, sondern betrifft auch die Versorgung der Insel mit Lebensmitteln, Trinkwasser und technischem Zubehör.

Allerdings können nur kleine Flugzeuge auf der privaten Flugpiste landen, welche die Insel mit dem nächsten internationalen Flughafen verbindet. Aufgrund fehlender Serviceeinrichtungen werden Privatinseln äußerst selten von Jets angeflogen. Eine Landebahn hat eine Minimumlänge von 500 bis 700 Metern, dementsprechend ist eine ausreichende Inselgröße Voraussetzung. Ein amüsantes Detail: Wenn die großen Landebahnen schon einmal da sind, werden sie manchmal auch zweckentfremdet genutzt, zum Beispiel als Fußballfeld oder zu einer geselligen Partie Crocket.

In jedem Fall bedürfen sie intensiver Pflege und beeinflussen das äußere Erscheinungsbild einer Insel. Der Nutzen einer eigenen Landebahn sollte also ausreichend groß sein, um diesen Negativeffekt zu kompensieren.

If it has its own airstrip, even the most remote island can be reached better. This is not only the case for the much more comfortable arrival of the owner, but also for the maintenance of the island, including the delivery of groceries, drinking water, and technical supplies.

However, only small planes can land on the private airstrip, which connects the island to the next international airport. Due to a lack of service facilities, jets will very rarely approach private islands. An airstrip has a minimal length of 1,600 to 2,300 feet, which is why a sufficient island size is a prerequisite. An amusing detail: When these large airstrips are already in place, they are sometimes used for alternate means, for instance as a football field or for a genial game of crocket.

In any case, they need intensive care and they alter the outward appearance of an island. The need for your own airstrip, then, should be sufficiently big, in order to compensate this negative effect.

D'ARROS	88
GALLOO ISLAND	90
KAIKOURA ISLAND	92
ALLAN ISLAND	93
SWAN ISLAND	94
MOTU NAO NAO	96
LITTLE DARBY ISLAND	97

AMIRANTES, SEYCHELLES
D'ARROS

Die Landepiste auf D'Arros ist zwar nicht asphaltiert, misst aber immerhin 975 Meter, was ungefähr der Breite der Insel entspricht. Einmal angekommen, hält man dieses Tor zur Außenwelt allerdings für überflüssig, denn man möchte nie wieder abfliegen.

The landing strip on D'Arros may not be asphalted, but measures at least 3,200 feet, which roughly corresponds to the width of the island. Once arrived, though, you will consider this gate to the outside world to be expendable, for you will never want to fly off again.

ISLANDS WITH THEIR OWN AIRSTRIPS

LAKE ONTARIO, NEW YORK, USA
GALLOO ISLAND

Spektakuläre Klippen, Sandstrand, saftige Wiesen und Laubwald wechseln sich auf Galloo Island im Lake Ontario ab. Schon 1889 baute man hier eine Lodge, die kürzlich komplett renoviert wurde und über sieben Gästezimmer verfügt. Die Insel eignet sich aufgrund ihrer Größe von etwa 18 Quadratkilometern zur Jagd oder als Ausgangspunkt für Rundflüge über die Seenlandschaft und Ausflüge ins benachbarte Kanada.

Spectacular cliffs, a sand beach, juicy meadows, and a broadleaf forest take turns on Galloo Island in Lake Ontario. As early as 1889, a lodge was built here which got completely renovated and now features seven guest rooms. The island is suited for hunting due to its size of about 7 square miles or as a starting point for sightseeing flights over the lake country and trips into neighboring Canada.

ISLANDS WITH THEIR OWN AIRSTRIPS 91

NORTH ISLAND, NEW ZEALAND
KAIKOURA ISLAND

Etwa 90 Kilometer nordöstlich von Auckland, an der Westküste von Great Barrier Island, liegt Kaikoura Island. Die Insel ist ein geschütztes Reservoir im Besitz der englischen Krone und wird von einer Treuhandgesellschaft verwaltet. Bedrohte Spezies, darunter bestimmte Enten- und Papageienarten, finden hier eine sichere Heimat.

Kaikoura Island is located about 56 miles northeast of Auckland off the west coast of Great Barrier Island. It is protected as a British Crown-owned preserve and managed by a trust. Its terrain provides an excellent refuge to endangered species, including certain types of ducks and parrots.

WASHINGTON, USA
ALLAN ISLAND

Inmitten der San Juan-Inseln zwischen Vancouver und Seattle liegt Allan Island an der amerikanischen Pazifikküste, geschützt durch die vorgelagerte Vancouver Island. Viele der Nachbarinseln sind bereits bebaut und das Festland ist touristisch gut erschlossen. Hauptattraktion ist das Whalewatching, denn in dieser Gegend ziehen Orcas ihre Bahnen.

Allan Island lies amidst the San Juan Islands between Vancouver and Seattle off the American Pacific Coast, protected by Vancouver Island, which is located upstream. Many of the neighboring countries are already developed and the mainland has been made available to tourists. The main attraction is whale watching due to the commonness of orcas in this area.

TASMANIA, AUSTRALIA
SWAN ISLAND

Vor 1843 tummelten sich auf Swan Island Aborigines, Robbenfänger, schiffbrüchige Seeleute und Forscher. Dann wurde der Leuchtturm mit einer damals einzigartigen Linsentechnik errichtet und blieb bis in die 1980er Jahre in Betrieb. Seitdem ist die Insel nahe der tasmanischen Küste ein privates Paradies zum Angeln, Schnorcheln oder Fliegen.

Before 1843, Swan Island was filled with aborigines, seal hunters, shipwrecked sailors, and explorers. Then the lighthouse was erected with a lens technology unique for its time and was in use up until the 1980s. Since then, the island close to the Tasmanian coast is a private paradise for fishing, snorkeling, or flying.

ISLANDS WITH THEIR OWN AIRSTRIPS 95

RAIATEA, FRENCH POLYNESIA
MOTU NAO NAO

Es gibt wohl weltweit kaum einen Landeanflug, der ein so farbintensives Bild aus Inseln und Atollen zeigt, wie der Anflug, der dem Eigentümer von Nao Nao vorbehalten ist. Grüne Inseln mit strahlend weißen Stränden reihen sich im Raiatea-Atoll aneinander, sanft umspült von knallig türkisfarbenem bis dunkelblau changierendem Wasser. Kürzer als hier kann der Weg von der Landebahn zum feinkörnigen Traumstrand nirgendwo sein.

There is probably no landing approach in the whole world offering such a vividly colored image of islands and atolls like the approach reserved for the owner of Nao Nao. Green islands with gleaming white beaches are strung together in the Raiatea Atoll, gently bathed by the brashly turquoise-colored to dark-blue shimmering water. The path from the landing strip to the fine-grained dream beach cannot be shorter anywhere else.

EXUMAS, BAHAMAS
LITTLE DARBY ISLAND

Little Darby Island gehört zu den letzten beinahe unberührten Naturparadiesen: Hier lassen sich Kolibris in ihrer natürlichen Umgebung beobachten, es gibt versteckte Höhlen zu entdecken, die türkis schimmernde Karibik lockt Schnorchler mit farbenfrohen Korallenriffen, und der weiße Sandstrand ist der perfekte Ort, um leuchtende Sonnenuntergänge zu erleben.

Little Darby Island belongs to the last almost unspoiled nature paradises: here hummingbirds appear in their natural habitat, there are hidden caves to be found, the Caribbean with its turquoise shimmer draws snorkelers with brightly colored coral reefs, and the white sand beach is the perfect place to experience luminous sunsets.

ATOLLE
ATOLLS

Atolle findet man im Pazifischen und im Indischen Ozean. Sie sind verbliebene Riffkränze gesunkener Vulkane und umschließen eine flache Lagune. Die auf den Korallenriffen gewachsenen Inseln sind entweder sehr lang und schmal, oder sie reihen sich wie kleine Perlen in Kreisform aneinander, nur durch schmale, herrlich türkisblaue Meeresärmchen getrennt. Die Eigentümer eines Atolls dürfen sich glücklich schätzen, ein einzigartiges Zuhause inmitten eines wunderschönen Biotops gefunden zu haben. Die strahlend weißen Strände und die prachtvoll bunten Unterwasserwelten in den Riffen sind vielfältig und artenreich.

Atolle wurden in den vergangenen Jahrzehnten oft als Kokosnussfarmen genutzt. Heute sind die verbliebenen Palmen für viele Paradiessuchende der Inbegriff des Inseltraumes. In den Lagunen lassen sich leicht kleine, geschützte Hafenanlagen errichten, außerdem bieten die oft sehr großen Atollinseln genügend Fläche für eine Landebahn. So ist sichergestellt, dass man sein privates Paradies leicht erreichen kann.

Ein von Herzen begeisterter Atollbesitzer war Marlon Brando, der seine tahitianische Insel Tetiaroa 38 Jahre lang liebte und mit seiner einheimischen Ehefrau Tarita ein Hotel auf ihr eröffnete. Tetiaroa war einst die Ferieninsel der tahitianischen Königsfamilie.

Atolls are to be found in the Pacific and Indian Ocean. They are the remaining reef wreaths of sunken volcanoes and enclose a flat lagoon. These islands, which have grown on coral reefs, are either very long or narrow, or they string together like little pearls in a circular shape, only divided by slim, wonderfully turquoise-blue estuaries. The owners of an atoll can count themselves lucky to have found a unique home amidst a gorgeous biotope. The gleaming white beaches and the magnificently colorful underwater worlds in the reefs are varied and rich in species.

In the past decades, atolls were often used as coconut tree farms. Today, the remaining palm trees are for many paradise seekers the embodiment of the island dream. Small, protected docks can be easily constructed in the lagoons; in addition, the often very large atolls offer enough area for an airstrip. This is to make sure that one's own private paradise can be easily reached.

Marlon Brando happened to be a wholeheartedly dedicated owner of an atoll. He loved his Tahitian island Tetiaroa for 38 years and opened a hotel there with his native wife Tarita. Once upon a time, Tetiaroa served as the holiday island of the Tahitian royal family.

TETIAROA ... 100

ST. JOSEPH ATOLL 102

TUPAI ... 104

KAIMBU ... 105

TAIARO .. 106

SOCIETY ISLANDS, FRENCH POLYNESIA
TETIAROA

Nachdem Marlon Brando „Meuterei auf der Bounty" gedreht hatte, wollte er sich vom Südpazifik nicht mehr trennen und unterschrieb für Tetiaroa einen Pachtvertrag über 99 Jahre. Dank dieser Exklusivität ist das Atoll bislang vom Massentourismus verschont geblieben und bietet Lebensraum für bedrohte Vogelarten.

After Marlon Brando shot "Mutiny on the Bounty," he refused to part with the South Pacific and signed a lease contract for Tetiaroa for 99 years. Thanks to this exclusivity, the atoll has so far escaped mass tourism and offers living space for endangered bird species.

102 ATOLLS

AMIRANTES, SEYCHELLES
ST. JOSEPH ATOLL

Zwar weist St. Joseph eine Gesamtfläche von 22,53 Quadratkilometern auf, allerdings lassen sich davon nur 1,39 Quadratkilometer als Insel nutzen: Der Rest sind Sandbänke und Korallenriffe. Wer nicht unter Kokospalmen übernachten möchte, muss den etwa 1 Kilometer breiten und 60 Meter tiefen Kanal nach D'Arros mit seinen komfortablen Villen überqueren.

The total area of St. Joseph may amount to 8.7 square miles, however, only 0.54 square miles of it can be used as an island: the rest are sand banks and coral reefs. Those who do not want to spend the night under coconut trees have to cross a canal that is about half a mile wide and 200 feet deep to reach D'Arros with its comfortable villas.

SOCIETY ISLANDS, FRENCH POLYNESIA
TUPAI

Der Legende nach sollen die Meuterer eines chilenischen Kriegsschiffes hier einst einen Schatz vergraben haben. Die Fläche, unter der er versteckt sein könnte, umfasst 11 Quadratkilometer, die hauptsächlich von einer Kokospalmenplantage bedeckt sind.

Legend has it, that mutineers from a Chilean warship once buried a treasure somewhere on this low-lying atoll. The area where it might be hidden amounts to 4.2 square miles, most of it occupied now by a coconut palm plantation.

FIJI
KAIMBU

Kaimbu verfügt über drei Bungalows und garantiert seinen Gästen ein Maximum an Privatsphäre, denn die nächste größere Fidschi-Insel, Vanua Balavu, liegt 56 km entfernt. Das Atoll ist zusammen mit seiner Schwesterinsel Yakata vulkanischen Ursprungs; helle Kalksteinfelsen und weiße Strände bilden einen traumhaften Farbkontrast zur üppigen Vegetation und der Lagune in schillerndem Blau.

Kaimbu features three bungalows and guarantees its guests the ultimate in privacy because the next larger Fijian island, Vanua Balavu, is more than 30 miles away. Together with its sister island of Yakata, the atoll is of volcanic origin. Bright limestone cliffs and white beaches create a striking color contrast to the lush vegetation and the brilliant blue lagoon.

TUAMOTU ARCHIPELAGO, FRENCH POLYNESIA
TAIARO

Das in Privatbesitz befindliche Taiaro-Atoll ist seit 1977 ein Biosphären-Reservat und steht unter dem Schutz der UNESCO. Seine außergewöhnliche Ringform ist vollkommen geschlossen, sodass die tiefe Lagune über keine Verbindung zum Meer verfügt.

The privately owned atoll of Taiaro has been a biosphere reserve and under protection by the UNESCO since 1977. Its remarkable ring shape is completely closed off, thus capping a connection between the deep lagoon and the sea.

ATOLLS 107

RESORT- UND HOTELINSELN
ISLANDS WITH RESORTS

Auf den kleinen und großen See-, Fluss- und Ozeaninseln aller Erdteile gibt es ein verlockend vielfältiges Angebot an Urlaubsherbergen: Es reicht vom einfachen Zeltresort, in dem man sich barfuß zum Lunch trifft und auf Zeitungen und Elektronik bewusst verzichtet, über komfortable Bungalowanlagen mit Internet, Pools und Restaurants bis hin zu den luxuriösen Spa-Resorts, in denen man in feinsten Wellness- und Fitnessanlagen regeneriert und sich von hochqualifizierten Bio-Köchen kulinarisch verwöhnen und zugleich entgiften lassen kann.

So unterschiedlich die Art der Unterkünfte ist, so groß ist auch die Preisspanne: Ob man 50 oder 10 000 Dollar pro Nacht investieren möchte, darüber entscheidet das eigene Portemonnaie. Hotelinseln sind beliebte Locations für Hochzeiten, Familien- oder Firmenevents sowie für Seminare oder Think Tanks – für fast jedes Ereignis gibt es einen Anbieter, der sich genau darauf spezialisiert hat.

Eine kleine Grundregel sollte man bei der Planung und Buchung bedenken: Je weniger Bebauung sich auf einer Insel findet, desto authentischer ist das Inselgefühl.

A compellingly diverse supply of vacation homes is to be found on the small and big lake islands, river isles, and ocean islands in all parts of the earth: It ranges from the simple tent resort, where one goes for lunch barefooted and consciously abandons newspapers and electronics, through comfortable bungalow constructions with internet, pools, and restaurants, right up to the luxurious spa resorts, where one is rejuvenated at the finest wellness and fitness sites and can treat oneself to some fine food by highly qualified cooks of organic food, which at the same time detoxifies the body.

As varied as the types of accommodations are, as wide is the price margin: one's own wallet determines whether one wants to invest 50 or 10,000 Dollars per night. Hotel islands are beloved locations for weddings, family or company events, as well as seminars or think tanks—almost every event has a provider who is specialized to hold it.

One small basic rule should be adhered to while planning and booking: the less cultivation there is on an island, the more authentic is the island feeling.

KOH DEK KOULE 110

MARINA CAY 111

FRÉGATE ISLAND 112

GUANA ISLAND 116

MIRIHI 118

NORTH ISLAND 120

SONEVA GILI 124

COUSINE ISLAND 126

MOTU TAUTAU 130

SIHANOUKVILLE, CAMBODIA
KOH DEK KOULE

Bei der Ausstattung der zwölf exotischen Suiten in diesem privaten Resort im Golf von Thailand legte man auf Authentizität besonderen Wert: Jeder Raum ist individuell mit asiatischen Antiquitäten ausgestattet, die Bettüberwürfe aus handgewebter Seide sind nach lokaler Tradition gefertigt und die Wände werden von chinesischen Kunstdrucken geschmückt.

The owners paid special attention to authenticity when they equipped the twelve exotic suites in this private resort in the Gulf of Thailand: every room is equipped individually with Asian antiques, the blankets are made from hand-woven silk and following local tradition, and the walls are adorned with Chinese art prints.

ISLANDS WITH RESORTS

BRITISH VIRGIN ISLANDS, CARIBBEAN
MARINA CAY

Marina Cay liegt an der Ostspitze von Tortola und erlangte – trotz seiner bescheidenen Größe von etwa 3 Hektar – als Schauplatz eines Romans und der dazugehörigen Verfilmung mit Sidney Poitier in den 50ern eine gewisse Berühmtheit. Exotische Blumen und Palmen umgeben das kleine Hotel im Stil eines charmanten Landhauses. Die Gäste der acht Zimmer erwartet das zwanglose Lebensgefühl der Karibik, kreolische Spezialitäten für den Gaumen und ein artenreiches Schnorchelgebiet mit beeindruckenden Farben. Dazu sorgen die Passatwinde rund um die Uhr für eine erfrischende Brise.

Marina Cay is located at the eastern tip of Tortola and—despite its modest size of about 7 acres—came to a certain prominence as the setting for a novel and subsequent film adaptation with Sidney Poitier from the '50s. Exotic flowers and palms surround the small hotel in the style of a charming country house. The casual sense of life of the Caribbean, Creole specialties for the taste buds, and a species-rich area for snorkeling with impressive colors await the guests of the eight rooms. In addition to that, trade winds provide a fresh breeze all the time.

MAHÉ GROUP, SEYCHELLES
FRÉGATE ISLAND

114　ISLANDS WITH RESORTS

FRÉGATE ISLAND ragt 125 Meter aus dem Indischen Ozean und gibt damit dem exklusiven Rock Spa auf dem Plateau einer Klippe seinen Namen. Die überwältigende Natur schafft die schönste Kulisse für das Areal aus kleinen Granit-Canyons, Wasserfällen, Pools und Terrassen, von denen sich ein weiter Blick übers Meer eröffnet. Die Gäste wohnen in 16 unterschiedlich großen und individuell gestalteten Villen.

FRÉGATE ISLAND towers 400 feet over the Indian Ocean and thereby gives the exclusive Rock Spa on the plateau of a cliff its name. Nature in all its splendor creates the most beautiful scenery for the area made of little granite canyons, waterfalls, pools, and terraces from which a singular look at the sea is possible. The guests live in 16 differently sized and individually designed villas.

BRITISH VIRGIN ISLANDS, CARIBBEAN
GUANA ISLAND

An die grünen Hügel dieser üppig bewaldeten Insel, die schon seit 70 Jahren in Familienbesitz ist, schmiegen sich Cottages aus weißem Stein mit idyllischen Terrassen und Villen mit privatem Strand oder einem eigenen Pool auf der Veranda. Das karibische Luxus-Resort vermittelt auf fast 3,5 Quadratkilometern und an sieben Stränden ein Gefühl völliger Privatsphäre und Exklusivität für maximal 32 Gäste.

Cottages made of white stone with idyllic terraces and villas with a private beach or a personal pool on the veranda snuggle up to the green hills of this lushly forested island, which has been family-owned for 70 years already. The Caribbean luxury resort imparts a sense of complete privacy and exclusivity to a maximum of 32 guests on almost 1.2 square miles and seven beaches.

ISLANDS WITH RESORTS 117

ARI ATOLL, MALDIVES
MIRIHI

Schon die Anreise per Wasserflugzeug mit der atemberaubenden Sicht auf die malerischen Atolle rund um Mirihi lässt die Gäste erahnen, dass sie auf dem Weg ins Paradies sind. Die 36 Bungalows sind dezent modern gestaltet, so dass nichts dem traumhaften Strand die Show stiehlt.

The arrival by water plane with a breathtaking sight of the picturesque atolls all around Mirihi already indicates to the guests that they are on their way to paradise. The 36 bungalows are designed in a discreetly modern fashion, so as not to upstage the dreamlike beach.

ISLANDS WITH RESORTS 119

PRASLIN REGION, SEYCHELLES
NORTH ISLAND

NORTH ISLAND geht mit seiner Verbindung aus Öko-Tourismus und Luxusurlaub innovative Wege. Die Spa-Behandlungen werden individuell auf den Gast abgestimmt, um die bestmögliche Erholung zu erzielen. Feinkörniger Sandstrand und unberührte Natur tun ein Übriges, um den Alltag weit hinter sich zu lassen. Bei der Ausstattung der elf Villen bestimmen Naturmaterialien und dezente Farben den eleganten Stil.

NORTH ISLAND takes innovative steps with its combination of eco-tourism and luxury vacation. The spa treatments are attuned to the individual guest, so as to achieve the best possible rest. A fine-grained sand beach and an unspoiled nature go one step further to leave everyday life far behind. Natural materials and discreet colors define the elegant style of the furnishings of the eleven villas.

MALÉ ATOLL, MALDIVES
SONEVA GILI

Die rund 50 Wasser-Villen und Privatresidenzen sind allesamt aus heimischen Naturmaterialien auf Stelzen erbaut und verbinden dank ihrer offenen Architektur Leben im Luxus und Leben in der Natur aufs Angenehmste. Ein romantisches Abendessen auf der Privatterrasse unter dem maledivischen Sternenhimmel ist kaum zu übertreffen.

All of the nearly 50 water villas and private residences on stilts are built from local natural materials and combine, thanks to their open architecture, a life of luxury with a life of nature in the most pleasant manner. A romantic dinner on the private terrace beneath the Maldivian starlit sky is almost unbeatable.

ISLANDS WITH RESORTS 125

PRASLIN REGION, SEYCHELLES
COUSINE ISLAND

COUSINE ISLAND ist nicht nur ein Reservat für Schildkröten, sondern auch ein exklusiver Rückzugsort für maximal acht Gäste, die sich in vier Villen im französischen Kolonialstil verwöhnen lassen können. Pool, Lounge und Bibliothek sind zentrale Treffpunkte, doch sonst genießt man die Insel ganz für sich und das mit gutem Gewissen: Die auf der Insel erwirtschafteten Gewinne werden für Naturschutzprojekte gespendet.

COUSINE ISLAND is not only a turtle reserve, but also an exclusive retreat for as much as eight guests. They can let themselves be spoiled in any of the four villas built in French colonial style. The pool, the lounge, and the library are central meeting points on this island which otherwise offers perfect solitude, and this with a good conscience: the profits generated on the island are invested into environmental safety projects.

ISLANDS WITH RESORTS 129

BORA BORA ATOLL, SOCIETY ISLANDS, FRENCH POLYNESIA
MOTU TAUTAU

Das exklusivste Resort von Französisch Polynesien, Le Taha'a, findet man auf der Motu Tautau. Die Bungalows setzte man als Wasserdorf in die Lagune, der Spa-Bereich fügt sich organisch in die naturbelassene Vegetation. Bei einer Massage am Strand blickt man am Horizont auf Bora Bora.

The most exclusive resort in French Polynesia, Le Taha'a, can be found on the Motu Tautau. Resembling a water village, the bungalows are located in the lagoon, and the spa area blends into the natural vegetation. While enjoying a massage on the beach, you can see Bora Bora on the horizon.

ISLANDS WITH RESORTS

SCHATZINSELN
TREASURE ISLANDS

Jede Insel hat ihre ganz eigene Geschichte. Manchmal ist sie von Sagen umhüllt, mit zwielichtigen Machenschaften legendärer Piraten verwoben oder liegt gänzlich im Dunkeln. Für den Eigentümer ist es ein spannendes Vergnügen, der Vergangenheit seiner Insel nachzuforschen – und manchmal finden sich dabei Hinweise auf einen Schatz, der seit vielen Jahren auf einen Finder wartet. Über Jahrhunderte hinweg wurden Inseln als Verstecke für kostbare Beuten genutzt, die im Eifer einer Verfolgungsjagd zurückgelassen werden mussten. Meist lagen diese Inseln sehr isoliert und weit ab von den Hauptschifffahrtsrouten. Ihre Abgelegenheit und ihre oft wilde Vegetation machten sie attraktiv für Piraten wie den skrupellosen Olivier Levasseur aka La Buse oder Captain William Kidd. Inseln, die über fruchtbares Land und Trinkwasser verfügten, boten ganzen Piratenmeuten die Möglichkeit, sich und ihre Ladung für eine Weile versteckt zu halten, bis sich die entstandene Aufregung nach dem Raubzug gelegt hatte.

Derart angenehme Inseln zogen auch Siedler und Farmer an, sodass viele Eilande früher oder später in Privatbesitz übergingen, als die Siedler das Eigentumsrecht und die entsprechenden Papiere beantragten. Heute, nach Generationen, ahnt wohl so mancher Inseleigentümer nicht, welche Kostbarkeiten sich vergraben im Schatten seiner Palmen oder tief in den Spalten eines felsigen Kliffs verbergen. Vielleicht sind viele von ihnen reicher, als sie sich zu erträumen wagen.

Every island has its very own history. Sometimes it is shrouded by legends, entangled with the dubious machinations of legendary pirates, or it lies completely in the dark. It is a gripping delight for the owner to probe the past of his island—and sometimes there are hints to be found towards a treasure which for many years has been waiting for a finder. Across centuries, islands were used as hiding places for valuable booties which had to be left behind in the heat of a chase. These islands often lay very isolated and far from the main shipping routes. Their remoteness and often rather wild vegetation made them attractive to pirates like the unscrupulous Olivier Levasseur aka "La Buse" or Captain William Kidd. Islands which featured fertile land and drinking water offered whole gangs of pirates the possibility of hiding themselves and their loot for a while, until the commotion brought up by the raid had settled.

Such pleasant islands also attracted settlers and farmers, so that many islands sooner or later were privately owned as settlers applied for ownership and the corresponding papers. Today, after so many generations, one or the other island owner may not suspect which valuables are buried in the shadows of his palm trees or are hidden deep in the crevices of a rocky cliff. Many of them may be richer than they dare to dream.

LORD HOWE ISLAND 134

OAK ISLAND 135

ISLA DE COCO 136

NORMAN ISLAND 138

TREASURE ISLANDS

TASMAN SEA, AUSTRALIA
LORD HOWE ISLAND

Nach der Entdeckung 1788 bildete sich Lord Howe Island, hunderte von Kilometern entfernt von den Küsten Australiens und Neuseelands, als Versorgungshafen für die damals florierende Walindustrie heraus. 1830 kenterte ein britischer Walfänger unweit der Insel. Die Mannschaft konnte sich retten – und wahrscheinlich auch die Goldmünzen, die sie zuvor verdient hatte. Heute werden auf der Insel Lodges vermietet – nicht nur für Schatzsucher.

Following its discovery in 1788, Lord Howe Island developed into a supply harbor for the then flourishing whale industry some hundred miles away from the coasts of Australia and New Zealand. In 1830, a British whaling ship capsized not far from the island. The crew could rescue themselves and probably also the gold coins they earned beforehand. Today, lodges are rented out

NOVA SCOTIA, CANADA
OAK ISLAND

Seit mehr als 200 Jahren tummeln sich Schatzsucher auf Oak Island, weil einst ein 16-jähriger behauptete, ein Loch entdeckt zu haben, in dem ein Schatz vergraben sein müsse. Selbst Präsident Franklin D. Roosevelt war mit einem Ausgrabungsteam auf der Insel. Wonach man sucht, ist unklar: Die Legenden reichen von den Juwelen Marie Antoinettes bis zum Heiligen Gral.

For more than 200 years, treasure hunters have been romping about on Oak Island, just because a 16-year-old once claimed to have found a hole wherein a treasure must have been buried. Even President Franklin D. Roosevelt visited the island with an excavation crew. What everyone is looking for is unclear: the legends range from the jewelry of Marie Antoinette to the Holy Grail.

PEARL ARCHIPELAGO, PANAMA
ISLA DE COCO

Im Jahr 1820 beauftragte der Vizekönig von Lima Captain Thompson, einen Kirchenschatz von Peru nach Mexiko zu transportieren. Der Seefahrer konnte der Versuchung nicht widerstehen, raubte den Schatz im Wert von rund 60 Millionen Dollar und vergrub ihn auf der Isla de Coco. Hunderte von Schatzjägern reisten zur Isla de Coco in Costa Rica – vergebens. Kürzlich gab ein Historiker den Hinweis, dass wohl die Isla de Coco in Panama die wahre Goldgrube sei.

In 1820, the Viceroy of Lima ordered Captain Thompson to transfer a treasury of the Church from Peru to Mexico. The sailor could not resist the temptation, stole the treasure at the value of around 60 million dollars and buried it on Isla de Coco. Hundreds of treasure hunters traveled to the Isla de Coco in Costa Rica, but to no avail. Recently, a historian pointed out that Isla de Coco in Panama might possibly be the actual gold mine.

TREASURE ISLANDS 137

BRITISH VIRGIN ISLANDS, CARIBBEAN
NORMAN ISLAND

NORMAN ISLAND ist so etwas wie der Prototyp aller Schatzinseln. Als Robert L. Stevenson seinen Piratenroman „Die Schatzinsel" schrieb, basierte die Idee auf einer selbstentworfenen Schatzkarte von Norman Island, die er für seinen Stiefsohn gezeichnet hatte. Auf der Insel selbst kursieren Legenden um einen Fischer, der während eines Sturms in einer Höhle Schutz gesucht hatte und am nächsten Morgen hinter abgebrochenen Felsbrocken Golddublonen fand. Segler schätzen Norman Island weniger wegen der literarischen Berühmtheit, sondern als idealen Stopp, um an der Beach Bar einen Drink zu nehmen.

NORMAN ISLAND is something like the prototype of all treasure islands. When Robert L. Stevenson wrote his pirate novel "Treasure Island," the idea was based on a self-made treasure map of Norman Island that he had drawn for his stepson. On the island itself, there are local legends about a fisherman who during a storm ran into a cave for shelter and, on the next day, found gold doubloons behind some broken rock fragments. Sailors appreciate Norman Island less because of its literary fame, but as an ideal breakpoint for taking a drink at the beach bar.

TREASURE ISLANDS 141

XXL-INSELN
XXL ISLANDS

Die größten Privatinseln haben eine Länge zwischen 100 und 200 Kilometern und sind bis zu 50 Kilometer breit – damit erwirbt man tatsächlich ein eigenes Reich. Je größer allerdings die Insel ist, desto leichter verflüchtigt sich manchmal das Inselgefühl: Die eigenen Ufer kann man vielleicht nur noch aus den Fenstern seines in hoher Blicklage gebauten Hauses oder nach dem Erklimmen eines Gipfels erspähen. Wenn die Natur die eigene Rieseninsel mit einer solchen Anhöhe beschenkt hat, dann ist es ein unbeschreibliches Vergnügen, den Blick weit über Baum- oder Palmwipfel bis hin zum Ozean schweifen zu lassen.

Die Isle of Eigg in Schottland ist 31 Quadratkilometer groß und ihr höchster Berggipfel 394 Meter hoch. Die Bewohner Eiggs konnten von hier schon in den vergangenen Jahrhunderten Freund und Feind von Weitem kommen sehen. Die weitläufige Farm- und Resortinsel Pohuenui in den Marlborough Sounds in Neuseeland befindet sich im Besitz einer europäischen Familie und ist mit einer Fläche von 2 000 Hektar und ihren grünen Hügeln mit Weiden und Wäldern eine imposante Schönheit. Inseln derartiger Größe bergen ein besonderes Erschließungspotential, das ihren Wert bedeutend erhöht. Es ist genügend Raum vorhanden für mehrere Wohnsitze oder sogar eine gesamte Ferienanlage. Selbst das Entstehen ganzer Dörfer ist nicht ausgeschlossen: Die italienische Insel Capri im Golf von Neapel, die zu Kaiser Tiberius' Zeiten in seinem Privatbesitz war, beherbergt heute rund 13 000 Einwohner.

Schier endlose Strandspaziergänge, Entdeckungsfahrten mit dem Jeep, ein Picknick im Wald oder ein Ausritt mit dem eigenen Pferd – die Unternehmungsmöglichkeiten auf einer großen Insel sind vielfältig und die absolute Privatsphäre ist gesichert. Passionierte Landschaftsgärtner oder Liebhaber der Tierzucht können sich uneingeschränkt entfalten. Und wer Wert auf eine unabhängige An- und Abreise legt, erwägt vielleicht eine eigene Landebahn oder eine großzügig angelegte Marina.

The largest private islands have a length of 60 to 120 miles and are up to 30 miles wide—this way, one really acquires a kingdom of one's own. However, the larger an island is, the easier the island feeling goes away sometimes: One's own shores can possibly only be spotted from the windows of a house which was built on a high viewing point, or after climbing a summit. If nature has endowed one's own giant island with such an elevation, this grants the indescribable joy to let one's eye wander over the tops of trees and palm trees right down to the ocean.

The size of the Isle of Eigg in Scotland amounts to 12 square miles and has its highest mountain peak at 1,290 feet. In the past centuries, the inhabitants of Eigg could already see from here the arrival of friends and foes. The spacious farm and resort island Pohuenui in the Marlborough Sounds of New Zealand is owned by an European family and is a starling beauty, given its size of 5,000 acres and its green hills with pastures and forests. Islands of such size are endowed with a special potential for cultivation, which increases their value exponentially. There is enough room for several residences or even for a whole holiday resort. Even the development of whole villages cannot be ruled out: the Italian island Capri in the Gulf of Naples, which during the times of Emperor Tiberius was in his private possession, nowadays accommodates around 13,000 inhabitants.

Simply endless walks on the beach, journeys of discovery with the jeep, a picnic in the forest, or going for a ride on one's own horse—the choice of activities on a large island is varied and absolute privacy is a given. Passionate landscapers or stockbreeding aficionados can express themselves completely. And those who value an independent arrival and departure might consider their own airstrip or a generously laid out marina.

MOUTON ISLAND 144

COOPER ISLAND 148

GARDINERS ISLAND 149

ISLA DE ALTAMURA 150

JAQUES COUSTEAU ISLAND 152

STONY ISLAND 154

TRAIGUEN ISLAND 155

ORONSAY 156

POHUENUI 158

ISLE OF EIGG 160

VATU VARA 161

NOVA SCOTIA, CANADA
MOUTON ISLAND

MOUTON ISLAND ist die größte Privatinsel an der kanadischen Ostküste. Der Einfluss des Golfstroms und der hohe Sonnenstand sorgen in diesen Breiten für ein gemäßigtes Atlantikklima, sodass der weiße Sandstrand, der ein Drittel des Ufers umsäumt, von Mai bis Oktober bei milden bis sommerlichen Temperaturen zum Sonnenbad lockt.

MOUTON ISLAND is the largest private island on the East Coast of Canada. The influence of the Gulf Stream and the high position of the sun offer a moderate Atlantic climate. With mild temperatures from May until October, the white sandy beach along one third of the shoreline provides an enticing spot for sunbathing.

XXL ISLANDS 147

BRITISH VIRGIN ISLANDS, CARIBBEAN
COOPER ISLAND

Einzigartige Korallenriffe und Tauchreviere mit mehreren Schiffswracks umgeben Cooper Island von allen Seiten. Ein Beach Club Resort und ein kleines Hotel mit zwangloser Atmosphäre machen die Insel zu einem familiären Treffpunkt für Segler und Taucher.

Unique coral reefs and diving areas with numerous shipwrecks surround Cooper Island on all sides. With a beach club resort and a small hotel with a casual atmosphere, the island is a popular meeting place for sailing and diving enthusiasts alike.

EAST HAMPTON, NEW YORK, USA
GARDINERS ISLAND

1639 ließ sich Lion Gardiner mit Erlaubnis des englischen Königshauses auf dieser Insel nieder und gründete damit die erste britische Siedlung im späteren Staat New York. Er legte Plantagen für Früchte, Tabak und Mais an, außerdem widmete er sich der Viehzucht. Bis heute ist Gardiners Island im Besitz seiner Nachkommen.

Thanks to a grant from the British crown, Lion Gardiner settled on this island in 1639 and founded the first British settlement in what would later become the State of New York. He cultivated fruit, tobacco, and corn, and also raised livestock. Gardiners Island remains in the possession of his descendants to this day.

BAJA CALIFORNIA, MEXICO
ISLA DE ALTAMURA

Rund 200 Kilometer nördlich vom Wendekreis des Krebses im Golf von Baja California liegt Altamura vor der Küste Mexikos und nimmt beinahe die doppelte Fläche von Manhattan ein. Das Naturjuwel ist eine der letzten Gegenden der Erde, die vor der Zerstörung durch den Menschen bewahrt geblieben ist. Weitläufige Sanddünen, geschützte Buchten und üppige Mangrovenhaine wechseln sich auf 50 Kilometern Länge ab. Im Wasser tummeln sich verschiedenste Fischarten bis hin zu Walen. Derzeit ist auf Altamura eine Viehfarm angesiedelt. Für die Zukunft ist angedacht, die Insel für ein luxuriöses Privatresort zu erschließen, wobei die Einhaltung modernster Umweltstandards zum Schutz der einzigartigen Natur höchste Priorität haben wird.

Roughly twice the size of Manhattan, Altamura is located about 125 miles north of the Tropic of Cancer in the Gulf of Baja California, just a few miles off the coast of Mexico. This natural gem is one of the last places on earth unspoiled by man. Extensive sand dunes, protected inlets, and lush mangrove forests alternate along its 31-mile length. The surrounding waters teem with a wide variety of fish and even whales. Altamura is presently home to a cattle ranch. Future plans include developing the island as a luxurious private resort, with the highest priority being given to complying with the latest environmental standards in order to protect the unique nature of the island.

BAJA CALIFORNIA, MEXICO
JAQUES COUSTEAU ISLAND

Eine einzigartig zerklüftete Hügelkette mit bis zu 640 Metern Höhe gibt dieser Insel, die bis vor kurzem noch Cerralvo hieß, ihr unverwechselbares Aussehen. Die Landschaft ist im Osten von schroffen Steilufern geprägt, während im Westen weiße Sandstrände zum Baden im Pazifik einladen.

A unique rugged range of hills up to 2,100 feet in altitude give this island, which not long ago carried the name Cerralvo, its unmistakable appearance. The landscape on the eastern side of the island has steep bluffs, while the western side has white sandy beaches that entice visitors to swim in the Pacific.

LAKE ONTARIO, NEW YORK, USA
STONY ISLAND

Nur wenigen Menschen ist ein Besuch auf Stony Island vergönnt: Sie müssen entweder Teilnehmer der Seminare und Think Tanks im Konferenzzentrum des Phillips Petroleum-Konzerns sein oder Freunde der Familie, die seit über 100 Jahren die andere Hälfte der wunderschönen Insel im Lake Ontario besitzt.

Very few people are given a chance to visit Stony Island: they need to be either participants in the seminars and think tanks at the Phillips Petroleum Conference Center or friends of the family which has owned the other half of this beautiful island in Lake Ontario for over 100 years.

CHONOS ARCHIPELAGO, CHILE
TRAIGUEN ISLAND

Traiguen Island ist Teil des Chonos-Archipels, einer Inselgruppe mit Flüssen, Seen und Wasserfällen, die in früheren Zeiten zur chilenischen Küste gehörte, dann aber überschwemmt und vom Festland abgetrennt wurde. Üppig bewachsene, weich geschwungene Hügelketten ziehen sich über die Insel, und tief eingeschnittene Buchten geben dem unregelmäßigen Ufer seine charakteristische Form.

Traiguen Island is part of the Chonos Archipelago of Chile, a group of islands with rivers, lakes, and waterfalls, the whole of which was once terra firma and part of the Chilean coast range before flooding separated it from the mainland. Lush greenery, forests, and rolling hills cover the island, while deeply cut inlets and large bays characterize the irregular shoreline.

SCOTLAND, UNITED KINGDOM
ORONSAY

Oronsay ist über einen unbefestigten Damm mit der Nachbarinsel Colonsay verbunden, der allerdings nur bei Ebbe genutzt werden kann. Fünf Menschen leben auf der Insel in einem kleinen Kloster, das Landwirtschaft betreibt. Historisch interessant sind die Funde aus der Mittelsteinzeit.

A muddy tidal causeway that is sufficient for crossing connects Oronsay to its neighboring island of Colonsay, but only when the tide is low. Five people live in a small monastery on the island, where they run a farm. Finds from the Mesolithic period are of historic interest.

MARLBOROUGH SOUNDS, NEW ZEALAND
POHUENUI

Der zukünftige Eigentümer von Pohuenui wird eine Insel erwerben, die etwa elfmal so groß ist wie das Fürstentum Monaco. Rund 50 Kilometer Küstenlinie mit versteckten Buchten ziehen sich um die wilde, grüne Berglandschaft. Im Wasser und an den Ufern haben Delfine, Wale, Pinguine und Seehunde ihr Revier. Für den Anfang kann die außergewöhnlich geformte Insel auch gemietet werden.

The future owner of Pohuenui will acquire an island that is eleven times as big as the Principality of Monaco. Around 30 miles of shoreline with secluded coves surround the lush, wild, and mountainous landscape. Dolphins, whales, penguins, and seals are common sights in the water and along the shore. For starters, the exceptionally shaped island can also be rented.

XXL ISLANDS 159

SCOTLAND, UNITED KINGDOM
ISLE OF EIGG

Die dramatischen Felsformationen, die aus der Moorlandschaft von Eigg aufragen, sind in ihrer geologischen Ausprägung einmalig in Europa. Wer nicht nur wegen der rauen Schönheit kommt, folgt auf der Insel den reichen historischen Spuren der Wikinger.

The dramatic cliff formations that jut up from the moorland plateau of Eigg are a geological feature unique in Europe. Many visit the island because of its rough beauty, while others are simply following the rich historic footsteps of the Vikings.

160 XXL ISLANDS

FIJI
VATU VARA

Ein erloschener Vulkan, der im Laufe der Jahrtausende von Korallenriffen bewachsen wurde, ist der Ursprung von Vatu Vara. Das ringförmige Riff mit seiner faszinierenden Unterwasserwelt bildet heute ein Atoll um die Insel. Steile Kliffs aus Korallenkalk und ein dichter, tropischer Dschungel, dazu feinsandige, weiße Strände machen die besondere Topographie dieses paradiesischen, unbewohnten Ortes in der Korosee aus. Der tafelbergartige Gipfel gab Vatu Vara den Beinamen „Hut-Insel" und prägt mit einer Höhe von 310 Metern die umgebende Skyline in einem Radius von 56 Kilometern.

The origin of Vatu Vara lies in an extinct volcano, which had been overgrown with coral reefs in the course of thousands of years. Today, the circular reef with its fascinating underwater world forms an atoll around the island. Steep cliffs made of coralline limestone and a dense, tropical jungle, as well as white beaches with fine sand constitute the special topography of this paradisiacal, uninhabited place in the Koro Sea. The table-mountain-like summit gave Vatu Vara the byname "Hat Island" and shapes with its height of 1,015 feet the surrounding skyline in a radius of 35 miles.

XXS-INSELN
XXS ISLANDS

Je kleiner das Eiland ist, desto intensiver erlebt der Eigentümer das Inselgefühl. Denn wer sein geliebtes Fleckchen Land in See oder Meer spazierend umrunden kann, vermag es innerlich zu umarmen. Und die nahegelegenen Ufer machen die Abgeschiedenheit vom Festland stets angenehm bewusst.

Eine kleine Insel ist wegen ihrer geringen Größe nicht immer günstiger im Erwerb als eine große – ihre Lage zählt mehr als ihre Fläche. Vor allem in beliebten Gegenden wie in den USA vor den zahlreichen Buchten Rhode Islands, in den Seen um Toronto in Kanadas Ontario oder in Europa sind zum Verkauf stehende Inseln eine Rarität. Selbst Kleinstinseln, etwa in der Lagune von Venedig, von wo aus man mit Leichtigkeit zu einem eleganten Abendessen in der Stadt ausfahren kann, oder in einem Schweizer See sind begehrte Kostbarkeiten.

Es ist empfehlenswert, eine Insel unter 10 000 Quadratmetern Fläche nur dann zu erwerben, wenn sie nahe dem Festland liegt. In weiter Entfernung zur Küste ist man schlechtem Wetter leicht erlegen, sofern keine größeren Baumbestände oder Anhöhen das Wohnhaus schützen. Abgesehen davon genießt man in der Nähe der Zivilisation ihre Vorteile: Stromversorgung, Internet, Hafenanlage. Im Allgemeinen ist es unproblematisch, die schon vorhandene Infrastruktur zu nutzen, und das kulturelle Leben der nächsten Stadt bietet eine willkommene Abwechslung zum Inselleben.

The smaller the island, the more intense the island feeling will be for the owner: Those who can easily go round their beloved piece of land, in a lake or on the sea, are able to embrace it internally. And the nearby shores always bring pleasantly to mind the seclusion from the mainland.

A little island is not always cheaper to buy than a large one because of its smaller size—its location counts more than its largeness. Islands on sale are especially rare in beloved areas like in front of the countless bays of Rhode Island in the US, in the lakes around Toronto in Canada's Ontario, or in Europe. Even the tiniest islands such as those in the lagoon of Venice, from where one can easily go out for an elegant dinner in the city, or in a Swiss lake, are coveted treasures.

It is recommended to only buy an island with a size of under 12,000 square yards if it is close to the mainland. Dealing with bad weather afar from the coast can be difficult if there is no large stock of trees or hills to protect the residence. Apart from this, there are advantages to be had from living close to civilization: electricity, internet, port facilities. On the whole, it is easy to use the infrastructure already in place. And to have access to the cultural life of the next city offers a welcome change from life on an island.

THOUSAND ISLANDS	164
SANDY SPIT	168
FISH ISLAND	170
POTATO ISLAND	171
CHAUVE SOURIS ISLAND	172
MOTU HAAPITI	174
MOTU TAPU	176
APPLE ISLAND	177
CONEY ISLAND	178
TRAGERØY	179
MAMENSLAE KLINE ISLAND	180
LE GOUFFRE	181
BUKKHOLMEN	182
ÎLE DE SALAGNON	183

NEW YORK, USA
THOUSAND ISLANDS

THOUSAND ISLANDS kündigt der Name an, doch genau genommen handelt es sich sogar um 1 793 Inseln, die teils auf amerikanischem, teils auf kanadischem Gebiet ein UNESCO-Biosphärenreservat bilden – dort, wo der St. Lawrence River aus dem Lake Ontario fließt. Während die größte Insel etwa 124 Quadratkilometer misst, finden auf der kleinsten nur ein Baum und zwei Sträucher Platz. Die gesamte Gegend ist als beliebte Ferienregion dicht besiedelt, sodass keine Langeweile aufkommt – egal wie klein das eigene Eiland ist.

THOUSAND ISLANDS is what the name advertises, but 1,793 of them are actually gathered here. They lie partly in Canadian and partly in U.S. territory and constitute, as a whole, a UNESCO biosphere reserve in the area where St. Lawrence River emanates from Lake Ontario. The largest of these islands measures about 48 square miles, the smallest one has just enough space for a tree and two bushes. As a favored holiday region, the whole area is so densely populated that it never gets boring—no matter how small your own island is.

XXS ISLANDS 167

BRITISH VIRGIN ISLANDS, CARRIBEAN
SANDY SPIT

Malte man sich die perfekte Karibikinsel in seinen Träumen aus, dann sähe sie aus wie Sandy Spit: einige kleine, dicht bewachsene Felsen, zwei einsame Kokospalmen und feiner weißer Sand, umgeben von türkis funkelndem Wasser. Segler besuchen dieses Idyll gern zum Schnorcheln oder für ein Picknick am Strand.

If you picture to yourself the Caribbean island of your dreams, it would look something like Sandy Spit: several small, densely overgrown rocks, two lonely coconut palms, and fine white sand, surrounded by turquoise glistening water. Sailors love to visit this idyll for snorkeling or for a picnic on the beach.

NOVA SCOTIA, CANADA
FISH ISLAND

Seit 100 Jahren ist Fish Island in der Mahone Bay in Privatbesitz und beweist: Die Lebensqualität auf einer Insel hat nicht unbedingt mit ihrer Größe zu tun. Der lebendige Ferienort Chester liegt nur einige Dutzend Meter entfernt, sodass man das Lieblingsrestaurant mit wenigen Paddelschlägen per Kanu erreichen kann.

Fish Island in the Mahone Bay has been privately owned for 100 years and proves: the quality of life on an island is not necessarily dependent on its size. The lively holiday spot Chester lies only a few dozen yards away, so that your favorite restaurant can be reached with a couple of strokes by canoe.

CONNECTICUT, USA
POTATO ISLAND

Potato Island besteht wie seine 22 bewohnten Nachbarinseln im Archipel der Thimble Islands aus rosafarbenem Granit. Sie waren einst die Spitzen der Hügelketten, die sich vor der letzten Eiszeit hier entlangzogen. Das Sommerhaus im typischen Stil der amerikanischen Ostküste stammt von 1912.

Potato Island, like its 22 inhabited neighboring islands in the archipelago of Thimble Islands, consists of rose-colored granite, which once made up the cusps of a chain of hills that drifted by before the last ice age. The summerhouse in the typical style of the American East Coast originates from 1912.

OFF PRASLIN, SEYCHELLES
CHAUVE SOURIS ISLAND

Chauve Souris Island ist zwar mit 0,7 Hektar wirklich winzig, doch der Besitzer hat durch Sandaufschüttung, Palmenanpflanzung und den Bau von zwei Luxusbungalows ein außergewöhnliches Ferienparadies geschaffen. Eines der ausgefallenen Zimmer, der „Pirate Room", ist direkt in die bestehende Felsformation hineingebaut. Honeymooner bevorzugen den abgelegenen „Shipwrecked Bungalow".

Chauve Souris Island may be really tiny with its 1.7 acres, but the owner constructed an exceptional holiday paradise by heaping up sand, planting palms, and constructing two luxury bungalows. One of the extraordinary rooms, the "Pirate Room," has been built directly into the existing rock formation. Honeymooners prefer the secluded "Shipwrecked Bungalow."

XXS ISLANDS 173

BORA BORA ATOLL, SOCIETY ISLANDS, FRENCH POLYNESIA
MOTU HAAPITI

Die beiden kleinen Motu Haapiti liegen geschützt in der Lagune des Bora Bora-Atolls, die je nach Wetter ein fantastisches Farbspiel von Türkis über Kobaltblau bis Violett vollführt. Die Villa und das Gästehaus auf der größeren Insel, umgeben von Kokosnusspalmen, Eisenbäumen und Scaevola-Sträuchern, sind regionaltypisch auf Stelzen gebaut, um die kühlende Brise der sanften Passatwinde zu nutzen. Schon beim Frühstück den Blick auf Bora Bora und den Mont Otemanu zu genießen, ist ein unbeschreiblicher Luxus.

Both of the small Motu Haapiti lie in the safety of the lagoon of the Bora Bora atoll which according to the weather showcases a fantastic play of colors from turquoise to cobalt blue to purple. The villa and the guesthouse on the larger island, surrounded by coconut palm trees, hornbeam trees, and fan-flowers, are build, as typical for the region, on stilts, in order to benefit from the cool breeze of the gentle trade winds. It is an indescribable luxury to enjoy the view at Bora Bora and the Mont Otemanu as early as breakfast time.

BORA BORA ATOLL, SOCIETY ISLANDS, FRENCH POLYNESIA
MOTU TAPU

Wer an die Südsee denkt, denkt an Tapu, denn diese Privatinsel ist die am häufigsten fotografierte Motu – wie die winzigen Inseln hier heißen – der Region. Der Zutritt ist Gästen ausgewählter Resorts und Gruppen mit Privateinladung vorbehalten.

Anyone who thinks of the South Pacific inevitably thinks of Tapu, for this private island is the most often photographed Motu—the name given here to those tiny islands—of the region. Access is exclusive to guests of select resorts and groups with private invitations.

NOVA SCOTIA, CANADA
APPLE ISLAND

Während die nur wenige Meter entfernte Nachbarinsel Oak Island für ihren mysteriösen Schatz berühmt ist, glänzt Apple Island in der Mahone Bay mit einer ausgefallenen Form. Wie ein Apfel mit etwas zu lang geratenem Stiel erstreckt sich das Inselchen über 2 Hektar. Ein Vorteil der überschaubaren Größe: Wer ein Haus in die Inselmitte baut, hat von allen Zimmern aus Meerblick.

Neighboring Oak Island may be famous for its mysterious treasure, but Apple Island in the Mahone Bay shines because of its unusual shape. Like an apple with a stem that is just a bit too long, this small island extends over 5 acres. One benefit of the island's manageable size: if you built a house in the middle of the island, you would have an ocean view from every room.

COUNTY CORK, IRELAND
CONEY ISLAND

Coney Island in der Roaringwater Bay profitiert nicht nur vom milden Klima, das der Golfstrom im äußersten Südwesten Irlands mit sich bringt, sondern ist dank seiner Lage zwischen Küste und Long Island auch vor den Naturgewalten des Atlantiks geschützt. Das alte Steinhaus hat der Besitzer um einen verglasten Wintergarten erweitert, von dem aus man das ganze Jahr über einen weiten Blick nach Süden genießt.

Coney Island in Roaringwater Bay not only benefits from the mild climate created by the Gulf Stream in the farthest southwest of Ireland, but is also protected from the forces of nature through its location between the coast and Long Island. The owner added a glassed winter garden to the old stone house from which, all year long, there is a wide view towards the South to be enjoyed.

TELEMARK, NORWAY
TRAGERØY

Jedes Klischee vom ruhigen skandinavischen Leben in unberührter Natur wird hier erfüllt, denn Tragerøy verfügt auf kleiner Fläche über Wald, felsige Buchten, einen natürlichen Hafen und eine leichte Anhöhe, von der aus man weit über die norwegische Küste blickt. Das landestypische, rot gestrichene Blockhaus gehört ebenso zum Traum vom Inselleben im hohen Norden wie das obligatorische Sauna-Häuschen: Es liegt auf einem winzigen Felsen, der per Steg mit der Insel verbunden ist.

Every cliché of a quiet Scandinavian life in unspoiled nature is realized here, as Tragerøy features, on a small area, a forest, rocky bays, a natural port, and a light rise from where one can see far beyond the Norwegian coast. The red-painted log cabin typical of the country belongs as much to the dream of an island life in the far north as the obligatory sauna cottage, which lies on a tiny rock connected to the island by way of a footbridge.

RHODE ISLAND, USA
MAMENSLAE KLINE ISLAND

Der Osten der USA ist dicht besiedelt und die Küstenregion so beliebt, dass selbst Felsen geschätzt und als Bauland genutzt werden. Mamenslae Kline Island ist voll erschlossen und groß genug für eine geräumige Villa, selbstverständlich mit Telefonanschluss und modernster Solarstromtechnologie.

The east of the U.S. is densely populated and the coastal area is so popular that even rocks are appreciated and used as building plots. Mamenslae Kline Island is completely developed and large enough for a spacious villa, of course with a telephone connection and the most modern solar energy technology.

BRITTANY, FRANCE
LE GOUFFRE

Über die Jahrtausende wurde Le Gouffre, eines der berühmtesten Fotomotive Nordfrankreichs, zur Halbinsel: Den Raum zwischen der einst zweigeteilten, kleinen Insel und der bretonischen Küste hat der Atlantik mit Kieseln und fossilem Material aufgefüllt, sodass die Bewohner heute, wenn sie das Festland erreichen wollen, bequem das Auto nutzen können.

Over the centuries, Le Gouffre, one of the most famous photo motifs of Northern France, turned into a peninsula: the earlier space between the two small islands and the Breton coast has been filled with pebbles and fossil material by the roaring Atlantic Ocean, thereby enabling contemporary residents to reach the mainland by car.

TELEMARK, NORWAY
BUKKHOLMEN

Bukkholmen am Skagerrak, nicht weit von dem malerischen Städtchen Kragerø, zählt zu den Juwelen unter den norwegischen Privatinseln. Der Eigentümer hat mehrere Felsinseln erworben, die Kleinste aber für sein eigenes Domizil genutzt. Man braucht also wirklich nicht viel Platz, um das Leben als Inselbesitzer zu genießen, solange man – wie hier – vor den Naturgewalten geschützt ist.

Located not far from the picturesque town of Kragerø, Bukkholmen belongs to the jewels among the private islands of Norway. The owner bought several rocky islands, but used the smallest one for his own domicile. Thus one does not really need a lot of space to enjoy life as the proprietor of an island, as long as one is protected from the forces of nature—just the way it is here.

LAKE GENEVA, SWITZERLAND

ÎLE DE SALAGNON

Salagnon wurde bereits in der zweiten Hälfte des 19. Jahrhunderts künstlich angelegt. Von hier aus bietet sich eine märchenhafte Kulisse mit Blick über den Genfer See und auf die Savoyer Alpen. Ein französischer Porträtmaler war von diesem Panorama so begeistert, als er um die Jahrhundertwende seinen Urlaub an der mondänen „Schweizer Riviera" verbrachte, dass er die Insel kaufte und darauf sein Traumhaus errichten ließ: eine Villa nach florentinischem Vorbild mit Terrassen, Pergolen, kleinen Statuen im Garten und einer herrschaftlichen Treppe, die hinab zum See führt. Der heutige Besitzer kennt die Insel nicht nur als Urlaubsresidenz, sondern hat hier seine Kindheit verbracht. Nur eine unschöne Erinnerung hat er an das Inselleben: Wenn er mit seiner Schwester bei stürmischer Witterung zur Schule rudern musste, kam es vor, dass die Kinder mitsamt ihren Schultaschen ins Wasser fielen.

Salagnon was artificially constructed as far back as the second part of the 19th century. The island offers a fairytale scenery with a view over Lake Geneva and the Savoy Alps. This extraordinary panorama inspired a French portrait painter during his holiday stay at the chic "Swiss Riviera" around the turn of the century. He bought the island and had himself a dream house built on it: a villa based on a Florentine model with terraces, pergolas, little statues in the garden, and grand stairs leading down to the lake. The present owner is familiar with the island not only as a holiday residence; he also spent his childhood here. He has only one unpleasant memory from the life on the island: sometimes, when he had to row his way to school with his sister during stormy weather, it so happened that the children fell into the water, along with their schoolbags.

FLUSS- UND SEEINSELN
LAKE AND RIVER ISLANDS

Weiße Strände, ringsherum das Meer und der Horizont in weiter Ferne – das klassische Bild einer Insel ist nicht das einzig Wahre. Es gibt auch unendlich viele wunderschöne Inseln und Inselchen in Flüssen und Seen. Sie haben ihren ganz eigenen Charakter und Reiz. Die Vegetation ist anders als die einer Ozeaninsel, denn durch die geschützte Lage entsteht oft eine üppige Laubbaumpracht, beispielsweise auf den Seeinseln Kanadas. Das Süßwasser lässt auch die Vegetation an den Ufern vielfältiger gedeihen, sodass sich hier häufig zarte Blumen und Kräuter finden. Ein hinreißendes Beispiel für eine Flussinsel ist die Île de Chantemesle in der Seine. Sie liegt in einer der bezauberndsten Regionen um Paris, zwischen La Roche-Guyon und Vetheuill. Schon die Impressionisten fühlten sich von der Schönheit der Landschaft angezogen, Monet lebte und arbeitete hier.

Das Leben auf einer See- oder Flussinsel ist oft sehr viel enger verbunden mit der nächstgelegenen Ortschaft auf dem Festland und deren Bewohnern. Die Nähe der Geschäfte, Restaurants und anderer Anziehungspunkte bietet viel Abwechslung. Der Aktionsradius auf dem Wasser ist kleiner, aber geschützter. Oft ist das See- und Flusswasser auch als Trinkwasser geeignet, was die Versorgung angenehm erleichtert. Ein weiterer Unterschied zwischen Inseln in Seen und denen im Ozean ist die Lage über dem Meeresspiegel. Fluss- und Seeinseln sind tidenunabhängig und liegen, wie im Falle der Alpensee-Inseln, 500 bis 1 000 Meter über dem Meeresspiegel.

White beaches, surrounded by the sea and with the horizon far away—the classic image of an island is not the only truth. There is also an infinite number of gorgeous big and small islands in rivers and lakes. They have their very own character and attraction. The vegetation differs from that of an ocean island, because due to the protected location a lush leaf tree splendor develops, for instance, on the lake islands of Canada. Fresh water animates the vegetation on the shores to flourish more variedly, so that delicate flowers and herbs can often be found here. An adorable example for a river lake is Île de Chantemesle in the Seine River. It is located in of the most magical regions around Paris, between La Roche-Guyon and Vetheuill. Even the impressionists were drawn to the beauty of the landscape. Monet lived and worked here.

Life on a lake or river island is often much more closely intertwined with the nearby village on the mainland and its inhabitants. The proximity to shops, restaurants, and other centers of attraction offers much variety. Another difference between islands in lakes and those on the ocean concerns the location above the sea level. River and lake islands are independent of tides and are located, as is the case with the alpine lake islands, 1,500 to 3,000 feet above sea level.

BIG LA MOUNA ISLAND 186

MUSKOKA'S ISLAND WORLD 188

ISOLE DI BRISSAGO 189

PARTRIDGE ISLAND 190

SCHLOSS MAUENSEE 192

UFENAU ... 193

SLEEPY COVE ISLAND 194

NOVA SCOTIA, CANADA
BIG LA MOUNA ISLAND

Für maximal 34 Familien soll Big La Mouna in den nächsten Jahren als Privatinsel erschlossen werden. Landestypische Blockhäuser unter Mischwald werden dann das Ufer säumen. Die Insel mit ihren verschwiegenen Buchten, altem Baumbestand und dem klaren Wasser des Ponhook Lake ist bis in den Herbst ein Ferienparadies für Wassersportler.

In the next few years, Big La Mouna will be opened up as a private island for up to 34 families. Log cabins amidst mixed woodland so typical of the country will then line the shore. With its secluded coves, ancient forests, and the clear waters of Ponhook Lake, the island is a vacation paradise for water sport enthusiasts well into the fall.

LAKE AND RIVER ISLANDS 187

ONTARIO, CANADA
MUSKOKA'S ISLAND WORLD

Vermutlich war es der Indianer Mesqua Ukee, der für eine Landschaft samt Fluss und See zum Namensgeber wurde. Die zahlreichen Gewässer in dieser Region und das dicht bewaldete, felsige Land boten dem Häuptling und seinen Vorfahren ideale Bedingungen zum Fischen und Jagen. Heute lebt man am touristisch gut erschlossenen Lake Muskoka in Nachbarschaft zu Prominenten aus dem Showgeschäft, die hier Ferienhäuser besitzen. Toronto liegt nur eine Autostunde entfernt, was den See bei den Großstädtern zum beliebten Ziel für Wochenendausflüge macht.

The name of this area is thought to have been derived from the Native American Mesqua Ukee. This tribe chief and his ancestors had an ideal hunting ground in the rocky, densely wooded region, and excellent fishing grounds in its many stretches of water. Nowadays, celebrities from show business, who have vacation homes here, make up the neighborhood of Lake Muskoka, which has been opened up for tourists. The short one-hour-ride by car from Toronto makes the lake a favorite destination for weekend trips among city people.

LAGO MAGGIORE, SWITZERLAND
ISOLE DI BRISSAGO

Die klimatischen Bedingungen am Lago Maggiore sind so mild, dass die Privateigentümer der beiden Brissago-Inseln im 19. Jahrhundert einen botanischen Garten anlegten, der heute mit über 1 700 Pflanzenarten aufwartet. Viele davon stammen aus subtropischen Gegenden, darunter Eukalyptus, Bambus und Lotusblüten. Während die Liebe zur Pflanzenwelt wohl eher auf den Herrn des Hauses zurückging, einen vermögenden Offizier, begeisterte sich seine Gattin, die deutsch-russische Baronin Antoinette de Saint Léger, für die schönen Künste. Um die Jahrhundertwende war sie schillernde Gastgeberin für Maler, Komponisten und Schriftsteller wie James Joyce oder Rainer Maria Rilke, die gerne auf der blühenden Inselresidenz weilten.

The climate conditions on Lago Maggiore are so mild that the private owners of the two Brissago Islands created a botanical garden in the 19th century. Today, that same garden boasts over 1,700 plant species, many of which come from subtropical areas and include eucalyptus, bamboo, and lotus flowers. While the love for the plant kingdom probably goes back to the landlord, a wealthy officer, his wife, the German-Russian Baroness Antoinette de Saint Léger was taken with the fine arts. At the turn of the century, she was an iridescent host to painters, composers, and authors like James Joyce or Rainer Maria Rilke who liked to spend their time on the blooming island residence.

NOVA SCOTIA, CANADA
PARTRIDGE ISLAND

Der Big Mushamush Lake, etwa 90 Autominuten von Halifax entfernt, ist in den Sommermonaten ein beliebtes Touristenziel. Dennoch blieb Partridge Island als Naturjuwel erhalten, mit einem dicht gewachsenen Mischwald und – eine Besonderheit für eine Seeinsel – einem kleinen weißen Sandstrand.

A 90 minute drive from Halifax, Big Mushamush Lake is a favorite tourist destination in the summer months. Yet Partridge Island, with its dense mixed forest, has been preserved as a natural gem. It even has a small white sandy beach—a rare feature for an island on a lake.

LAKE AND RIVER ISLANDS 191

LUCERNE, SWITZERLAND
SCHLOSS MAUENSEE

Als der heutige Besitzer seine Insel zum ersten Mal sah, war er ein Wehrpflichtiger in der Schweizer Armee, der den Auftrag hatte, im Morgengrauen Schloss Mauensee einzunehmen. Das liegt mehr als 40 Jahre zurück. Ende der 90er stand die Insel dann zum Verkauf. Das idyllisch gelegene Anwesen mit einer Geschichte, die bis ins Mittelalter reicht, hatte den jungen Soldaten so beeindruckt, dass er sich sofort an jenen Morgen zurückerinnerte und nicht lange zögerte: Nach vielen Jahren im Ausland lebt er heute auf dem beschaulichen Mauensee und widmet sich dem Sammeln zeitgenössischer chinesischer Kunst.

When the present owner first laid eyes on his island, he was a draftee in the Swiss army who was on a mission to take over Schloss Mauensee at dawn. This happened more than 40 years ago. By the end of the '90s, the island was for sale. The idyllically situated estate with a history that goes back to the Middle Ages impressed the young soldier so much that he immediately remembered that very morning and did not hesitate much longer: After many years spent abroad, he now lives on the tranquil Mauensee and dedicates himself to collecting contemporary Chinese art.

LAKE ZURICH, SWITZERLAND
UFENAU

Das nahe gelegene Kloster Einsiedeln ist seit mehr als 1 000 Jahren Eigentümer von Ufenau und sorgt dafür, dass die größte Insel der Schweiz der Öffentlichkeit zugänglich bleibt. Die kleine Kapelle und die Kirche, die auf Ruinen eines römischen Tempels aus dem 2. Jahrhundert steht, sollen Orte der meditativen Einkehr sein, können aber auch für Hochzeiten genutzt werden. Für die Einkehr der anderen Art bietet sich das barocke Wirtshaus „Haus zu den zwei Raben" an.

Located nearby, Einsiedeln Abbey has owned Ufenau for more than a thousand years and ensures that the largest island in Switzerland remains accessible to the public. The small chapel and the church that was built on the ruins of a 2nd-century Roman temple were devised as a perfect refuge for meditation, but can also be used for weddings. The baroque tavern "Haus zu den zwei Raben" (The Two Ravens) offers a different kind of retreat.

NOVA SCOTIA, CANADA
SLEEPY COVE ISLAND

Jedes Klischee vom Urlaub in der kanadischen Waldeinsamkeit erfüllt sich auf Sleepy Cove. Zwar ist die Provinzhauptstadt Halifax nur 20 Kilometer entfernt, doch bereits die Anreise mit einem Kanu oder Ruderboot lässt die Nähe zur Zivilisation völlig vergessen. Einige Entenpaare und Eichhörnchen wird man auf der Insel antreffen, aber abgesehen davon hält Sleepy Cove, was der Name verspricht: Abgeschiedenheit, Ruhe und Ursprünglichkeit. Das Leben in der rustikalen Blockhütte, umringt von hohem Nadelwald, scheint wie aus dem Bilderbuch, außer dass es durch Strom und fließendes, warmes Wasser deutlich bequemer gemacht wird. Gäste, die sich ihr Abendessen nicht direkt aus dem Wasser fischen wollen, können zum Proviantnachschub auf die Läden an der Festlandküste zurückgreifen.

Sleepy Cove Island epitomizes every cliché of vacationing in the solitude of the Canadian forest. Although Halifax, the provincial capital, is a mere 12 miles away, traveling to the island by canoe or rowboat makes it easy for visitors to forget how close civilization actually is. Aside from the ducks and squirrels that you are likely to see on the island, Sleepy Cove lives up to its name and offers seclusion, tranquility, and pristine beauty. Life in the rustic log cabin surrounded by tall conifers seems like a page out of a storybook—except that it offers the creature such comforts as electricity and hot running water. Guests who don't feel like fishing for their dinner can make a trip to the mainland and buy provisions from the stores.

SELBSTVERSORGER-INSELN
SELF-SUFFICIENT ISLANDS

Wenn eine Insel dem Eigentümer nicht nur einen Lebensraum, sondern auch Trinkwasser und ausreichend Nahrung bieten kann, um sich gesund ernähren zu können, sprechen wir von einer Selbstversorgerinsel.

Jede Familie, die schon einmal versucht hat, ohne den Zukauf von Lebensmitteln auszukommen, weiß, dass man nach einiger Zeit den für die eigene Versorgung besten Weg findet, zu wirtschaften. Ob man sich nun entschließt, Obst und Gemüse anzubauen, aber Fleisch und Milch auf dem Festland zu erwerben, oder ob man selbst Tiere hält; ob man den Fisch aus den umliegenden Gewässern isst oder den der Fischer aus dem nächsten Ort – wie weit man sich auf der eigenen Insel unabhängig macht, hängt von der persönlichen Lebensführung und den eigenen Ansprüchen ab. Und auch die Inseltechnik bedarf individueller Planung: Bevorzugt man eine Hightech-Satellitenanlage oder ein schlichtes Telefon, eine Solaranlage oder einen Generator?

Es gibt in fast jeder Klimazone Inseln, die sich als Selbstversorgerinsel nutzen lassen würden. Eine bewährte Faustregel aus den Siedlerzeiten des 19. Jahrhunderts besagt, dass ein Hektar Land ausreicht, um eine Familie zu ernähren. Egal ob der Inseleigentümer sich der intensiven Landarbeit annehmen möchte oder auf seinem Eiland die Entspannung sucht – es ist ein erfüllendes Gefühl, auf die Reichtümer der Natur zurückgreifen zu können.

If an island can offer its owner not just a living space, but also drinking water and enough food to be able to have a healthy diet, we are talking about a self-sufficient island.

Every family which already tried to get by without the additional purchase of groceries knows that, after a while, one finds the best way to provide for oneself: Whether one decides to grow fruits and vegetables while buying meat and milk on the mainland, or to keep animals for oneself; whether one eats the fish from the surrounding waters or the fish from the fishermen of the next village—how independent one wants to be on one's own island depends on the personal lifestyle and standards. And the island technology also requires individual planning: is a high tech satellite station preferred, or a simple telephone, a solar plant or a generator?

Almost every climate zone features islands that can be used as self-sufficient islands. A reliable rule of thumb from the days of the settlers of the 19th century goes thus: 2.5 acres of land are enough to feed one family. Regardless of whether the island owner wants to take up intensive farm work or seeks relaxation on his island—it is a rewarding feeling to be able to fall back on the riches of nature.

ÎLE BINIGUET	198
SANTA CRISTINA	200
LÄNGGRIEN	204
SANDA ISLAND	206
INSEL LIEBITZ	210
DEENISH ISLAND	212
ÎLE SAINT-RIOM	214
MOTU TOAHOTU	216
ROBINS ISLAND	218

BRITTANY, FRANCE
ÎLE BINIGUET

Von einem kleinen Hafen über Wohnhäuser, landwirtschaftliche Gebäude und insgesamt 18 Hektar Land, die sich größtenteils zum Gartenbau eignen, gibt es auf dieser malerischen Insel nahe Brehat alles, was man braucht, um eine längere Zeit autark zu leben. Dank der Kapelle muss man Biniguet selbst sonntags nicht verlassen.

There is pretty much everything one needs on this picturesque island near Brehat to live a self-sufficient life: from a little harbor to tenements, agricultural buildings, and altogether 44.4 acres of land, most of which is suited for gardening. Thanks to the chapel, even on Sundays one does not have to leave Biniguet.

VENICE LAGOON, ITALY
SANTA CRISTINA

SANTA CRISTINA in der Lagune von Venedig war schon seit dem 7. Jahrhundert von Benediktinernonnen bewohnt, blieb aber nach 1452 über lange Zeit verwaist. In der zweiten Hälfte des 20. Jahrhunderts entdeckte ein Privatmann seine Liebe zu der Insel und gebot dem drohenden Verfall durch umfangreiche Eindämmungen und Uferbefestigungen Einhalt. Dadurch entstanden Gemüsefelder, Obstgärten und Pools zur Fisch- und Muschelzucht. Rund um das Wohnhaus dehnen sich heute Weinfelder aus, in denen exquisite Cabernet-, Merlot- und Chardonnaytrauben wachsen.

SANTA CRISTINA, in the lagoon of Venice, had been inhabited by Benedictine nuns from as early as the 7th century, but remained abandoned for a long time from 1452. In the second part of the 20th century, a private business man discovered his love for the island and halted the imminent decline through extensive embankments and shoreline stabilization. Thereby, vegetable fields, orchards, and pools for fish farming and mussel cultivation came about. Today, vineyards are stretched out all around the residence, within which exquisite Cabernet, Merlot, and Chardonnay grapes grow.

SELF-SUFFICIENT ISLANDS 203

AARE RIVER, SOLOTHURN, SWITZERLAND
LÄNGGRIEN

Schon in fünfter Generation wird Länggrien von einer Familie bewohnt, die als Bio-Bauern und Caterer für private Feste auf der Insel ihr Einkommen bestreitet.

Länggrien is inhabited by a family earning their income as organic farmers and caterers for private festivities. They have already been on the island for five generations.

SELF-SUFFICIENT ISLANDS

SCOTLAND, UNITED KINGDOM
SANDA ISLAND

SANDA ISLAND verfügt im Zentrum der Insel über etwa 18 Hektar bebaubares Ackerland. Die restliche Fläche, insgesamt sind es fast 160 Hektar, erstreckt sich über hügelige Wiesen, auf denen in Bilderbuchlandschaften Schafe weiden. Gäste, die den rauen Charme nahe der schottischen Küste ganz ursprünglich erleben wollen, können sich in renovierten Zimmern im traditionellen Bauernhaus einmieten. Wer die Insel erwirbt, darf damit auch den Titel „Laird of Sanda" führen, eigene Briefmarken herausgeben und Goldmünzen prägen.

SANDA ISLAND has around 45 acres of arable farmland in the middle, while the rest of the island's almost 400 acres extends across hilly meadows, on which sheep graze in an idyllic setting. Guests who want to experience the rough charm of the Scottish coast in a completely pristine form can rent renovated rooms in a traditional farmhouse. Whoever buys the island is allowed to carry the title "Laird of Sanda," issue his own stamps, and strike his own gold coins.

SELF-SUFFICIENT ISLANDS 209

OFF RÜGEN, MECKLENBURG-WEST POMERANIA, GERMANY
INSEL LIEBITZ

Etwa einen Kilometer vor Rügen, der größten deutschen Insel, liegt Liebitz im Nationalpark Vorpommersche Boddenlandschaft. Behutsam erschuf der Privateigentümer einen Hof mit großer Gartenanlage und vielen Hecken, in denen große Kolonien von Brutvögeln Unterschlupf finden.

Liebitz is located in the Western Pomerania Lagoon Area National Park, just over a half mile off Rügen, the largest island in Germany. The private owner has created a farm with extensive gardens and numerous hedges, which provide shelter to large colonies of birds.

KENMARE BAY, COUNTY KERRY, IRELAND
DEENISH ISLAND

Deenish Island ist ein Paradebeispiel für eine autarke Insel. Der kleine Bauernhof, bestehend aus mehreren schiefergedeckten Wohn- und Wirtschaftsgebäuden, deckt seinen Stromverbrauch durch Solarenergie und einen Generator, der mit Windkraft betrieben wird. Die Trinkwasserversorgung ist über einen Brunnen gewährleistet. 20 Hektar fruchtbares Land stehen zur Verfügung, auf denen unter anderem ein weitläufiger Obstgarten angelegt ist. Dort, wo Felder nicht mehr genutzt werden, wachsen Farne und Brombeersträucher. Dadurch, dass neben den Privatbesitzern nur wenig Menschen auf die Insel kommen, haben Seevögel hier ideale Brutbedingungen, sodass sich seltene und teils vom Aussterben bedrohte Arten angesiedelt haben. Deenish Island wurde daher von der EU zum Vogelschutzgebiet erklärt.

Deenish Island is the perfect example of a self-sufficient island. Consisting of several slate-roofed residential and storage buildings, the small farm generates its own electric power using a solar system and a wind-powered generator. A well supplies drinking water for the whole island. The farmers have 51 acres of fertile land at their disposal, including an extensive orchard. Ferns and blackberry bushes have taken over fallow fields. Because the island is in private hands and receives only a few visitors besides the owners, it offers the ideal conditions for sea birds, and its breeding grounds have attracted various rare and endangered species. The EU has thus declared Deenish Island a Special Protection Area and bird sanctuary.

BRITTANY, FRANCE
ÎLE SAINT-RIOM

Wo vor hunderten von Jahren Mönche lebten, entstand um 1900 auf den alten Grundmauern ein kleiner Hof, der Landwirtschaft betreibt – vorwiegend Kartoffelbau. Durch die geschützte Lage im Golf von St. Malo werden auf Saint-Riom drei Ernten pro Jahr eingefahren.

Home to monks centuries before, a small farm was built on the old foundation walls of the monastery in 1900 and now primarily grows potatoes. Thanks to its protected location in the Gulf of Saint-Malo, the farm on Saint-Riom brings in three harvests per year.

SELF-SUFFICIENT ISLANDS 215

RAIATEA, FRENCH POLYNESIA
MOTU TOAHOTU

Im Riffgürtel von Tahaa liegt Toahotu, umgeben von Korallenriffen und einer vielfältigen Fischwelt. Schnorchler finden in dem außerordentlich klaren, türkisblauen Wasser ideale Bedingungen. Der Eigentümer hat sich einen tropischen Garten angelegt, in dem er verschiedene Gemüsesorten anbaut, daneben wachsen auf dem fruchtbaren Inselboden Vanilleschoten und Kokospalmen. Wasserbecken zur Fischzucht runden das alternative und entspannende Lebenskonzept eines Selbstversorgers in der Südsee ab.

Located in the reef belt of Tahaa, Toahotu is surrounded by coral reefs and various species of fish. Snorkelers will find ideal conditions in the exceptionally clear, turquoise-blue water. The owner has built himself a tropical garden in which he grows various vegetables. Right next to it, vanilla beans and coconut palm trees grow on the fertile ground of the island. Water basins for fish farming complete the alternative and relaxing attitude to life of a self-supporter in the South Seas.

LONG ISLAND SOUND, NEW YORK, USA
ROBINS ISLAND

Ein Finanzmann aus New York ist der gegenwärtige Eigentümer von Robins Island. Er investiert seit den 90ern beachtliche Summen in die Wiederherstellung der jahrelang vernachlässigten Insel. So wurden beispielsweise fremde Grasarten durch heimische ersetzt und ausgewachsene Eichen eingepflanzt, um frühere Rodungen auszugleichen. Mit fast 2 Quadratkilometern Fläche ist die Insel groß genug, um Wild und Fasane zu jagen.

A New York financier is the present owner of Robins Island. Since the 1990s he has invested significant amounts to restore the island, which had been neglected for years. For example non-native grasses have been replaced by native species and mature oaks have been transplanted onto the island to reforest areas that had been cleared in the past. An area of 0.8 acres makes the island large enough for hunting wild animals and pheasants.

DIE GÄRTEN DER SELBSTVERSORGERINSELN IN DREI VERSCHIEDENEN KLIMAZONEN
SELF-SUFFICIENT ISLAND GARDENS IN THREE DIFFERENT CLIMATIC ZONES

GEMÄSSIGTE ZONE
TEMPERATE ZONE

Extreme Temperaturen und Niederschläge sind hier selten, die Mitteltemperatur liegt zwischen 0 und 20 °C. Es gibt sommergrüne Wälder, warmtemperierte Feuchtwälder und Steppen. Das milde, aber feuchte Klima mit viel Tageslicht eignet sich gut für den Ackerbau.

Extreme temperatures and precipitation are rare in these regions and the average temperature ranges from 30 to 70 °F. Lush, green forests, warm wetlands, and steppes characterize them. The mild yet moist climate and the abundance of daylight present good conditions for farming.

SUBTROPISCHE ZONE
SUBTROPICAL ZONE

Hier herrschen lange, sehr warme Sommer mit wenig Niederschlag und meist milde und feuchte Winter vor. Die Artenvielfalt der Vegetation ist eher gering: Regengrüne Wälder, Savannen und Halbwüsten wechseln sich ab.

Long, warm summers and mild, moist winters are predominant in the subtropical zone. The diversity of flora is relatively low: green rain forests alternate with savannas and semi-deserts.

TROPISCHE ZONE
TROPICAL ZONE

In der wärmsten Klimazone der Erde herrscht das Tageszeitenklima vor: Zwischen Tag und Nacht sind die Temperaturunterschiede größer als die Schwankungen zwischen den monatlichen Durchschnitten. Die Vegetation reicht von immergrünen Regenwäldern bis zu Savannen. Über 40 Prozent der Menschheit lebt in den Tropen – mit steigender Tendenz.

Most of the earth's warmest climatic zone is characterized by the diurnal climate: The temperature differences between night and day are bigger than the differences between the monthly averages. The vegetation ranges from evergreen rain forests to savannas. More than 40 percent of the world's population lives in the tropics—with an upward trend.

SELF-SUFFICIENT ISLANDS

PHOTO CREDITS AND IMPRINT

Cover photo (Tetiaroa) by Farhad Vladi
Back cover photos (Thousand Islands) by Farhad Vladi; (Frégate Island) courtesy of Frégate Island Private

All photos by Farhad Vladi

Other photos:

pp. 28–29 (Musha Cay) provided by owner

pp. 32–33 (Necker Island) courtesy of Virgin Limited Edition

pp. 36–37 (Laucala) by No Limit Fotodesign/ courtesy of Laucala Island Resort Limited

pp. 40–41 (Tiano) by Bruce Jarvis (aerial view by F. Vladi)

pp. 44–45 (Little Whale Cay) p. 44 middle right by John Warburton-Lee; others provided by owner (aerial view by F. Vladi)

p. 46 (Île de Chantemesle) aerial view provided by owner

p. 47 (Bonefish Cay) provided by owner

p. 48 (Hunt Island) by David Burns/ Vladi Private Islands (aerial view by F. Vladi)

pp. 50–53 (Forsyth Island) by David Burns/ Vladi Private Islands

p. 54 (Melody Key) provided by owner

p. 55 (Tagomago) provided by owner

p. 60 (Isla de sa Ferradura) provided by owner (aerial view by F. Vladi)

pp. 66–67 (Kaulbach Island) by David Burns/ Vladi Private Islands (aerial view by F. Vladi)

pp. 68–71 (Buck Island) provided by owner

pp. 106–107 (Taiaro) by Antoine Grondeau

p. 110 (Koh Dek Koule) provided by resort

pp. 112–115 (Frégate Island) courtesy of Frégate Island Private

pp. 116–117 (Guana Island) provided by resort

pp. 118–119 (Mirihi) by Martin Nicholas Kunz (excepting aerial view, provided by resort)

pp. 120–123 (North Island) pp. 120–121 and 123 by Andrew Howard; p. 122 bottom by Dana Allen/ all courtesy of Wilderness Safaris

pp. 124–125 (Soneva Gili) provided by Six Senses Hotels, Resorts & Spas

pp. 8, 126–129 (Cousine Island) p. 129 by Martin Harvey 2004; others provided by resort

pp. 130–131 (Motu Tautau) provided by resort

p. 134 (Lord Howe Island) courtesy of www.lordhoweisland.info

pp. 144–147 (Mouton Island) by David Burns/ Vladi Private Islands

p. 155 (Traiguen Island) by Andrés Lama

p. 161 middle (Vatu Vara) courtesy of www.vatuvara.com

p. 174 top (Motu Haapiti) provided by owner

pp. 186–187 (Big La Mouna Island) by David Burns/ Vladi Private Islands (aerial view by F. Vladi)

pp. 190–191 (Partridge Island) by David Burns/ Vladi Private Islands (aerial view by F. Vladi)

p. 194–195 (Sleepy Cove Island) by David Burns/ Vladi Private Islands (aerial view by F. Vladi)

p. 200–203 (Santa Cristina) Studio Lanza/ provided by owner (aerial view by F. Vladi)

pp. 210–211 (Insel Liebitz) by Luftbild Rügen

p. 219 (Illustrations) by Andreas Piel

Edited by Farhad Vladi

Texts by Martina Matthiesen, Dr. Simone Bischoff

Copy Editing: Dr. Simone Bischoff, Janosch Müller

Editorial Management: Claude Flachsbarth, Sabine Rollinger

Creative Direction: Martin Nicholas Kunz

Layout & Prepress: Christin Steirat

Photo Editing: David Burghardt

Imaging: Tridix, Berlin

Translations by Dr. Asokan Nirmalarajah, Heather Bock

Published by teNeues Publishing Group

teNeues Verlag GmbH + Co. KG
Am Selder 37, 47906 Kempen, Germany
Phone: +49 (0)2152 916 0, Fax: +49 (0)2152 916 111
e-mail: books@teneues.de

Press department: Andrea Rehn
Phone: +49 (0)2152 916 202
e-mail: arehn@teneues.de

teNeues Digital Media GmbH
Kohlfurter Straße 41-43, 10999 Berlin, Germany
Phone: +49 (0)30 700 77 65 0

teNeues Publishing Company
7 West 18th Street, New York, NY 10011, USA
Phone: +1 212 627 9090, Fax: +1 212 627 9511

teNeues Publishing UK Ltd.
21 Marlowe Court, Lymer Avenue, London SE19 1LP, UK
Phone: +44 (0)20 8670 7522, Fax: +44 (0)20 8670 7523

teNeues France S.A.R.L.
39, rue des Billets, 18250 Henrichemont, France
Phone: +33 (0)2 4826 9348, Fax: +33 (0)1 7072 3482

www.teneues.com

© 2011 Farhad Vladi. All rights reserved.
© 2011 teNeues Verlag GmbH + Co. KG, Kempen
ISBN: 9 78-3-8327-9586-3
Library of Congress Control Number: 2011944168

Printed in the Czech Republic.

Picture and text rights reserved for all countries.

No part of this publication may be reproduced in any manner whatsoever. All rights reserved.

While we strive for utmost precision in every detail, we cannot be held responsible for any inaccuracies, neither for any subsequent loss or damage arising.

Bibliographic information published by the Deutsche Nationalbibliothek.

The Deutsche Nationalbibliothek lists this publication in the Deutsche Nationalbibliografie; detailed bibliographic data are available in the Internet at http://dnb.d-nb.de.